TEXAS HILL
COUNTRY WINERIES

Sip & Savor Texas!

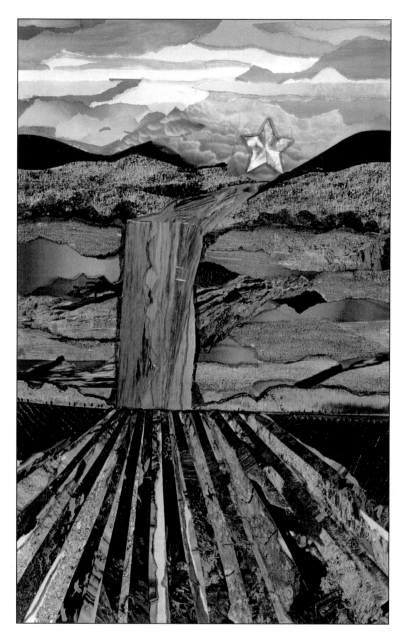

This image was used by Fall Creek Vineyards in a poster for its winery and wine label art. The poster was originally produced with the caption, "Where the Sky Fell in Love with the Earth and Gave Birth to Wine." The image and caption definitely capture the ambiance at Fall Creek Vineyards but also applies to the Texas hill country as a whole. The poster image was made from a tapestry assembled by artist Shanny Lott. (Courtesy of Fall Creek Vineyards.)

ON THE FRONT COVER: (clockwise from top left) Texas grapes on the vine (courtesy of Ben Smusz), Sister Creek Vineyards sign (courtesy of James Skogsberg), view of vineyard (courtesy of Driftwood Vineyards; see page 25), Merrill Bonarrigo and wine press (courtesy of Messina Hof Winery), barrel room (courtesy of Spicewood Vineyards).

ON THE BACK COVER: (from left to right) Dry Comal Creek Vineyards (author's collection), T.V. Munson, the grape man of Texas (courtesy of Dr. Roy Renfro; see page 16), harvesting in the vineyard (courtesy of Driftwood Vineyards).

IMAGES
of Modern America

TEXAS HILL
COUNTRY WINERIES

Russell D. Kane

ARCADIA
PUBLISHING

Copyright © 2014 by Russell D. Kane
ISBN 978-1-4671-3273-2

Published by Arcadia Publishing
Charleston, South Carolina

Printed in the United States of America

Library of Congress Control Number: 2014957378

For all general information, please contact Arcadia Publishing:
Telephone 843-853-2070
Fax 843-853-0044
E-mail sales@arcadiapublishing.com
For customer service and orders:
Toll-Free 1-888-313-2665

Visit us on the Internet at www.arcadiapublishing.com

*To the men and women, past and present, who
contributed to Texas's wine legacy, which made today's
Texas hill country winery experience possible.*

CONTENTS

ACKNOWLEDGMENTS

During the research phase for this book, many people and organizations provided guidance, assistance, and support, and they should be acknowledged. My thanks go to Ed and Susan Auler (Fall Creek Vineyards), Evelyn Oberhelman (Bell Mountain Vineyards), and Dr. Richard and Bunny Becker (Becker Vineyards) for their personal accounts of the history of the Texas hill country wineries; and Jerry Watson and Larry Uhlig for introducing me to the German wine culture that helped give Texas its start.

I thank my wife, Delia Cuellar, for her careful review and editing of my manuscript and images. I recognize James Skogsberg, my longtime personal friend and primary photographer for this book. I also thank those who contributed multiple photographs or maps from their professional collections: Ben Smusz, Miguel Lecuona, Matt McGinnis, Jeff Cope, and Billy Burdett. Unless otherwise noted, the images are from the author's collection.

I also acknowledge the assistance and/or support of the following organizations: the Texas Hill Country Wineries, the Wine Society of Texas, and the Texas Wine and Grape Growers Association.

Finally, I want to thank the winery and vineyard owners, winemakers, their employees, individuals, and organizations that contributed time, information, and photographs acknowledged herein. This is their story that I am honored to tell.

INTRODUCTION

The Texas hill country winery experience is a relatively new phenomenon, having evolved from a "restart" of the Texas wine industry in the mid-1970s. At that time, almost simultaneously, many states began to explore growing grapes and making wine.

An event that helped to kick-start these rudimentary efforts into local winemaking is now referred to as "The Judgment of Paris"; an event that took place in 1976, the nation's bicentennial. "The Judgment," as it is often called by wine aficionados, refers to a wine competition held in Paris by Steven Spurrier, a wine merchant and bon vivant. In this competition, wines from fledgling California vintners won a miraculous victory (as judged by the French themselves) over wines from many of their top-ranked chateaux of Bordeaux and Burgundy. As a result of this milestone event, there was a wave of optimism in states all around America, leading many to try their hand at local winegrowing and winemaking.

Creating a respectable new wine region is no small task; California has been at it for over 100 years, and Europe has had centuries to do so. It requires learning about the adaptability of grapevines to new locales, with different soil and weather conditions, while also expanding knowledge of new viticultural practices to handle the plethora of local diseases and disorders that can afflict grapevines. Such efforts proved more difficult than many had anticipated, with results better in some states than in others. The Finger Lakes region of New York, Columbia Valley in Washington, and Willamette Valley in Oregon achieved success in the 1980s and 1990s.

Luckily, Texas has a long farming legacy, a deep-seeded pioneering spirit, and a tradition of agricultural grit and determination. In the 1970s and 1980s, the Texas winegrowing renaissance focused on efforts to use the same grape varieties common in France and California: Chardonnay, Pinot Noir, Cabernet Sauvignon, and Merlot. With some noteworthy successes, it would take Texas another 20 years to ultimately realize that it was not Napa or Bordeaux, and that it was sure as heck not Burgundy. It had to find grape varietals native to a Mediterranean climate more closely resembling that of Texas. These included grape varieties such as Viognier, Roussanne, Vermentino, and Trebbiano for making white wines, and Tempranillo, Syrah, Mourvèdre, Sangiovese, Dolcetto, Aglianico, and more to use in its reds. All of these grapes have one thing in common: a love of Texas's hot weather, sunny skies, and sandy, limestone-encrusted soils.

The Texas hill country is an uplifted portion of central Texas defined by arid, hilly landscape and picturesque limestone ledges. It is a region where elements of great vistas and tourism combine with winemaking and culinary diversity. By the late-2000s, to the surprise of many that envisioned Texas as only a bourbon and beer state, the Texas hill country emerged as a leading wine and culinary travel destination that could compete on a global scale.

In 2007, Orbitz "Food & Wine Index of the United States" conducted a survey of hotel, flight, and travel package bookings. From 2005 to 2007, it was no surprise that the survey showed that California's Napa Valley was the fastest-growing destination. However, the survey also showed that the American region ranked second fastest in growth in that time was a relatively unknown

newcomer: the Texas hill country. It identified this region as encompassing the areas of central Texas around Fredericksburg, Dripping Springs, and Marble Falls.

Fueling both the winery activity in central Texas and the overall Texas wine experience have been the impressive gains in grape growing and winemaking statewide. Current statistics indicate that Texas is now in a neck-and-neck battle with Virginia for the number five spot in wine production among American states, behind the well-known top four states of California, Washington, New York, and Oregon. Texas is the seventh-ranked state in the cultivation of wine grapes and fourth nationally in wine consumption, looking seriously at the number three slot.

In April 2014, the Texas hill country turned heads in the wine world when *Wine Enthusiast* magazine placed the region on its annual top-10 list of "must-see" wine country destinations. The hill country was among trendy emerging wine regions such as Greece and Baja, Mexico, and more well-established and acknowledged wine regions such as Sonoma County, California, Mendoza in Argentina, and Barossa Valley in Australia.

But, how does Texas hill country wine stack up in quality against wines from key wine-producing regions? Increasingly, Texas hill country wineries are sending their wines to out-of-state and international competitions to find out. Gold medals and even double golds have come from prestigious competitions in California and New York. In 2013, in a similar manner to the Judgment of Paris, the mantle of respectability was placed on Texas wine. In France, the Lyon International Wine Competition bestowed on Pedernales Cellars, a Texas hill country winery, an impressive grand gold award for its 2012 Viognier Reserve. It beat out all of the French Viognier wines in the competition.

At the time of this writing, the number of Texas hill country wineries is around 50, and there are over 300 wineries statewide. The hill country offers wine tourists a 25-county region with many attributes of the wine regions of southern Europe and California, characterized by rolling hills, limestone outcroppings, sandy soils, arid climate, native vegetation, and a maze of well-paved rural roads.

In the mid-1800s, German and Italian emigrant farmers brought European wine culture with them to Texas, and many settled in the hill country. After all, wine had always been a part of their everyday life. Many brought grapevines from their homeland, but these European varieties generally did not flourish in Texas. These classic "vinifera" grapes of Europe were limited by the state's variable weather conditions and then-unknown diseases, which would only begin to be addressed in recent decades.

Many Texas settlers continued by harvesting and processing native grapes that, according to land impresario Stephen F. Austin, grew prolifically in Texas during his time. Others pursued hybrid grapes (usually amalgams of French and American varieties) that could better handle the growing conditions here and resulted in wines that were closer to what they remembered from their European grapes.

But, the "genesis moment" in Texas wine occurred still further back, in the 1600s. Spanish missionaries followed conquistadors into the frontier lands of northern Mexico that would ultimately become Texas. The missionaries brought their own form of wine culture that was a requisite in the sacraments of the Catholic Church. They trekked vines by horseback to El Paso del Norte on the shores of the wild river now known as the Rio Grande and started Texas's first vineyards.

Those with little knowledge of the Texas wine experience may quibble about the state's place in the modern wine world; however, Texas wines are now bolstered by their recent emergence into the upper echelon of American winemaking and the confirmation of Texas's wine quality. The Texas hill country wineries welcome those from near and far to enjoy their wines—a literal taste of Texas to be sipped and savored.

One

THE TEXAS WINE LEGACY

WHERE IT ALL STARTED

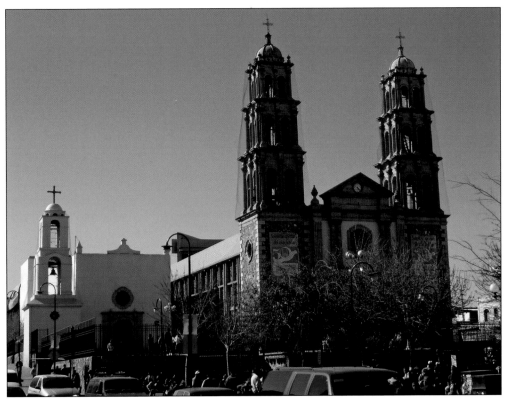

The Texas hill country wineries did not develop overnight. These central Texas wineries developed on the legacy of wine culture and activity that started with the Spanish missionaries who first brought grape growing and winemaking to El Paso del Norte in 1659. They established the Mission Nuestra Señora de Guadalupe (pictured) in Ciudad Juarez, Mexico, and vineyards on the banks of the Rio Grande (then called Rio del Norte) around present-day El Paso, Texas. The mission vineyards in Texas were planted nearly 100 years before Spanish missionaries established the first vineyards in California. (Courtesy of François Hirsch.)

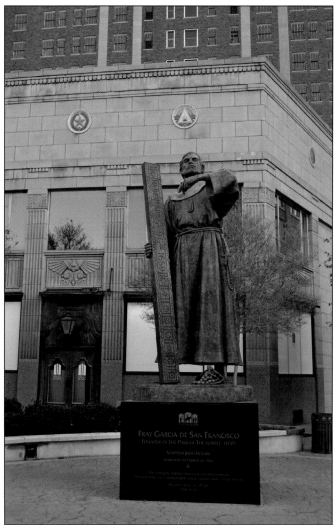

Fr. Garcia de San Francisco y Zuñiga, Fr. Juan de Salazar, and 10 Christianized Native families trekked northward across Mexico until they reached the Rio Grande at El Paso del Norte. In his settlement, Father Garcia established vineyards that supplied grapes for sacramental wines. Shown here is a statue of Garcia at Mills Plaza in El Paso. (Courtesy of Douglas Billings.)

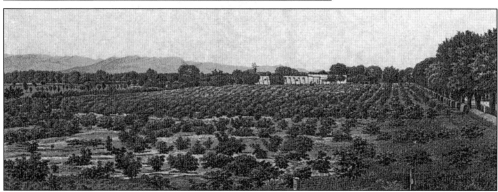

Father Garcia's vineyards were the first planted in the territory that later became the state of Texas in 1845. In the 1800s, commercial vineyards and wineries near El Paso flourished. The vineyard seen here on a souvenir postcard illustrates how the commercial El Paso vineyards looked in 1887, with bush-trained vines surrounded by fruit trees. (Courtesy of Texas Western Press.)

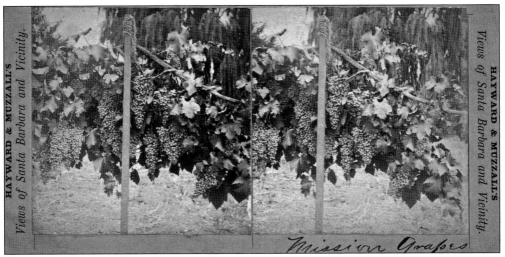

Mission vineyards at El Paso del Norte, like those later in California, were planted with cuttings of what were called "mission grapes." The mission grapevine seen here around 1875 is from a California vineyard. DNA tests indicate the mission grape, also called Criolla, was derived from Listan Prieto vines that came to the New World from Spain. (Courtesy of New York Public Library Digital Gallery.)

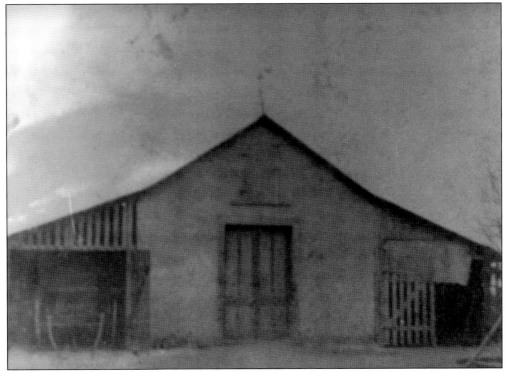

European farmers came to Texas in the 1800s, bringing with them a second wave of wine culture. Francesco Quaglia (later changed to Qualia) came to Texas from his native Italy via Mexico. In 1883, he established his vineyard and, shortly thereafter, the Val Verde Winery in Del Rio. The original winery building (pictured) was made from adobe bricks. It remains part of the winery today. (Courtesy of Val Verde Winery.)

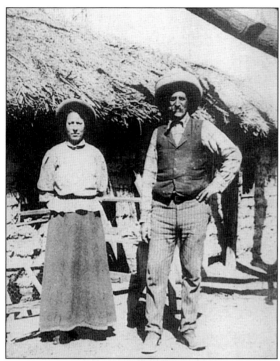

Francesco Quaglia poses with his wife, Mary, in the 1890s. Their vineyard was planted with local Lenoir (Black Spanish) cuttings that continue today, with the later addition of Herbemont and Blanc Du Bois. Val Verde Winery is the longest continuously operated winery in Texas and is one of the oldest continuously operating North American wineries. (Courtesy of Val Verde Winery.)

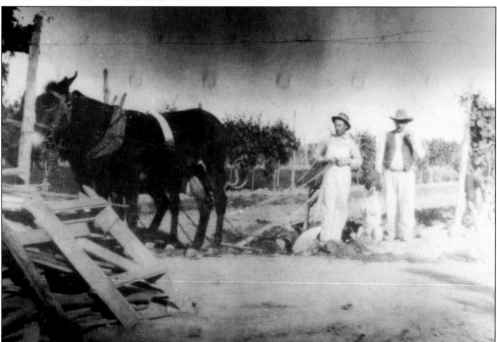

Francesco (right), his son Louis Qualia (left), and dog Prince are seen in the vineyard plowing around in the first decade of the 1900s. The vineyard had 30-foot-wide vine row spacings that were used to farm vegetables for market. Val Verde Winery was able to stay in business during Prohibition by selling sacramental and medicinal wines and grapes for personal winemaking and from other farming activities. (Courtesy of Val Verde Winery.)

German immigrants like John Berger, seen here on the right in the 1890s, established Texas vineyards and wineries. Berger settled in Columbus County, just inland from the Gulf Coast. Starting in the 1830s, many German settlers continued westward to New Braunfels and Fredericksburg in the Texas hill country. They brought with them a culture that depended on wine as a staple of daily life. (Courtesy of Earlene Drumm.)

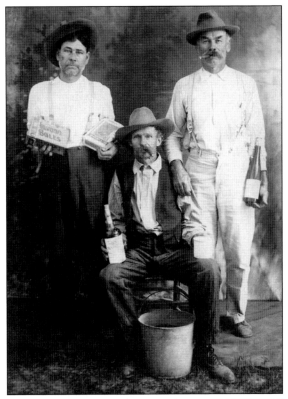

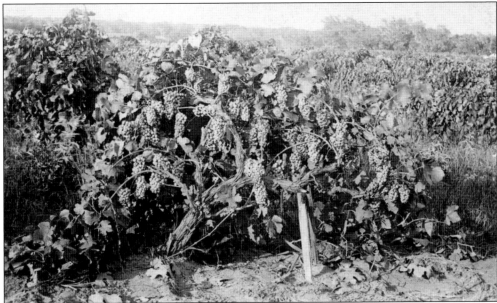

John Berger brought grapevine cuttings from Germany, intending to use them to make white wine. When they failed, Berger's heritage caused him to search for another white wine grape. He traveled to California, visiting other German vintner settlements around Los Angeles, and returned with cuttings of Herbemont vines for his vineyard, shown here in the 1900s. (Courtesy of Earlene Drumm.)

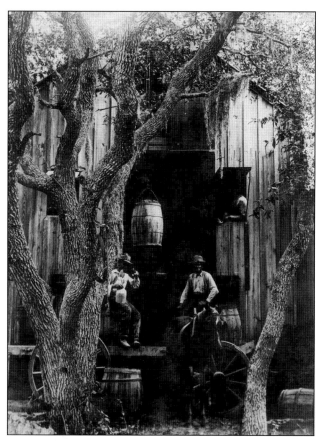

It is estimated that about 30 Texas wineries, like Berger's Bernardo Vineyard winery (pictured), operated commercially until the early 1900s. At that time, prohibition started in Texas before the start of national Prohibition. This winery was a multilevel building used for crushing grapes and for the storage of wine in barrels. (Courtesy of Earlene Drumm.)

Another German vintner, Frank Laake, started his Oak Hill Vineyard and winery operation in New Ulm in 1878. This wine label indicates that Laake made wine from Elvicand, a hybrid grape developed in 1885 by Texas grape horticulturalist T.V. Munson in Denison. Elvicand received favorable reports in Texas and California for its use in lighter white wines. (Courtesy of Lee Roy Schutte.)

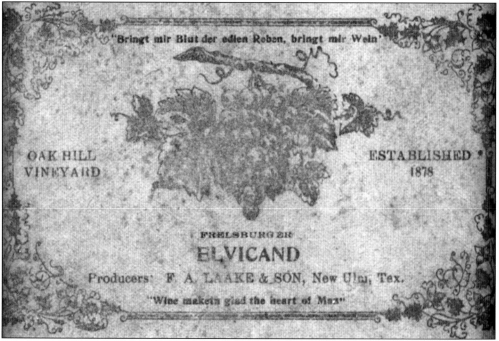

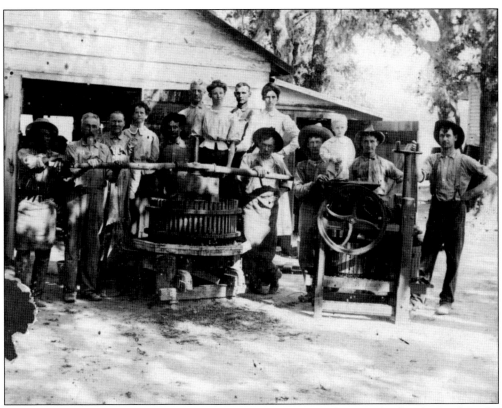

Grapes are being crushed at the Oak Hill Vineyard winery in a photograph taken by Frank Laake on August 3, 1910. It shows the use of basket presses in the winemaking operation. As in many smaller vineyards and wineries today in Texas, harvest and crush are group activities. (Courtesy of Lee Roy Schutte.)

Italian immigrants came to Texas and went west from Dallas, settling in Montague County, south of the Red River. In 1883, when Jack Fenoglio arrived there, he reportedly told his fellow Italians, "This soil will grow grapes." Here, Louis (left), Randy, and Tilda Nobile make wine in the 1950s using methods similar to those of their ancestors. (Courtesy of Montague Historical Commission.)

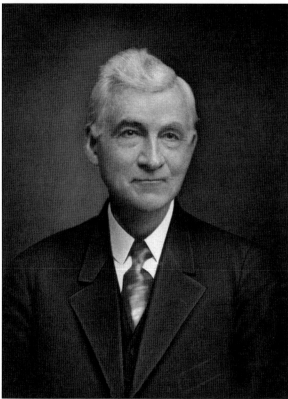

As early as the 1850s, grape arbors, like this present-day one at Fort Belknap in north Texas, were constructed. Meetings and celebrations were held in the arbor's cool shade. The metal structure holding up the arbor was built in 1940. The age of this arbor with a three-foot-diameter trunk is not known. (Courtesy of Bobby Cox.)

Thomas Volney Munson (1843–1913) collected, categorized, and bred Native American grapes. Munson's greatest achievement was providing the French vineyards with phylloxera-resistant rootstock from wild Texas grapes. This allowed vineyards across Europe to recover from the devastating blight of the 1800s. France later presented Munson the Chevalier du Mérite Agricole of the French Legion of Honor. (Courtesy of Roy Renfro, Grayson College.)

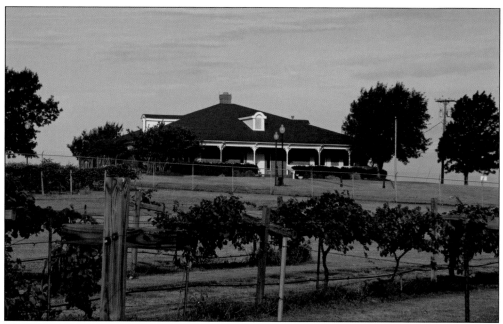

The Munson T.V. Memorial Vineyard was established in 1974 at Grayson College in memory of T.V. Munson. He developed over 300 varieties of mostly wild American grapes and hybrids. He hoped to provide Texas farmers with year-round grape crops. Currently, over 60 of the Munson varieties are in the memorial vineyard. (Courtesy of T.V. Munson Memorial Vineyard, Grayson College.)

Wines for the Fastidious

We make a specialty of. Our wines are pure. They are genuine. We have no use for imitations. Neither have you. What we sell you can always depend upon as right. The liquors which we sell at low prices will give you health as well as satisfaction.

No orders solicited from prohibition territory.

BROADWAY BAR, R. L. Rich, Prop.

In 1895, well in advance of the start of national Prohibition, 53 of the 239 counties in Texas were "dry" in regards to the sale of alcohol and another 79 counties were partly dry. In 1914, this *Cameron Herald* advertisement for wine at the Broadway Bar indicates that wine was not sold in the "prohibited territories." (Courtesy of the *Cameron Herald*.)

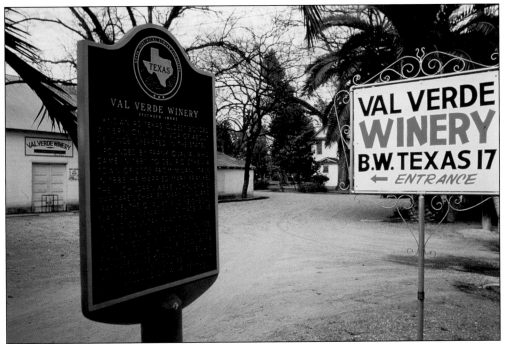

Val Verde Winery was the only Texas winery to survive national Prohibition (1920–1933). After Prohibition, the Qualia family did not realize that its winery needed to be re-licensed, as one was not required previously. As shown here, their winery later received post-Prohibition license No. 17. (Courtesy of Ben Smusz.)

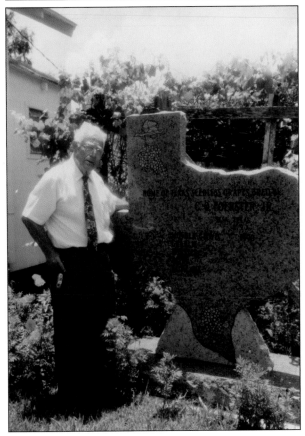

Beginning in 1938, C.O. Foerster Jr. hybridized grapes in south Texas in search of a table grape for the Lower Rio Grande Valley. He successfully crossed the wild Mustang grape and European vinifera grapes to produce five varieties of commercial quality. Foerster is seen here in 1993. (Courtesy of Texas Wine and Grape Growers Association.)

A grape research program was conducted by Texas A&M at Montague from 1939 to 1963. Uriel A. Randolph, seen here in the 1950s, tested hundreds of grape varieties and established the superiority of Favorite and Carmen grapes and rootstocks from Dog Ridge and other wild Texas grapes. Extensive research projects on pruning, fertilization, and pest management were conducted. (Courtesy of Montague Historical Commission.)

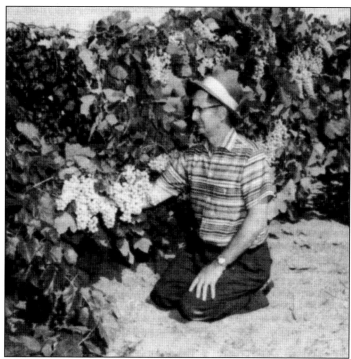

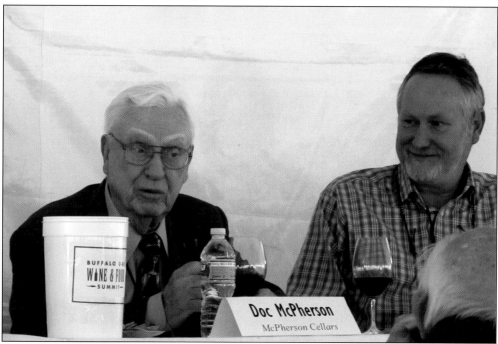

The "father of the modern Texas wine industry" was Dr. Clinton "Doc" McPherson, a professor in the chemistry department of Texas Tech University in Lubbock. He, along with professors Robert Reed, Dr. Roy Mitchell, and others, started research programs to investigate Texas grape growing and winemaking. Some of the first "modern" Texas wines were made in a basement laboratory in the university's chemistry building. McPherson is seen here in 2010 with his son Kim.

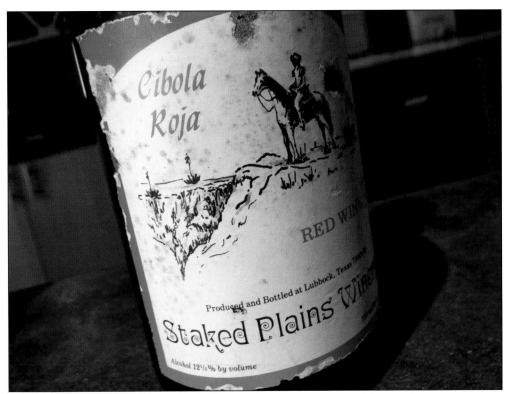

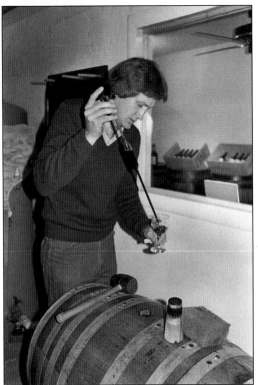

In 1976, Doc McPherson, Robert Reed, Roy Mitchell, and investors started Llano Estacado Winery in Lubbock. It was named after the area's high tablelands called Llano Estacado by the Spanish conquistadors. The area was also known as Staked Plains. In 1977, before its first vinifera grape planting, Llano Estacado bottled its first wines, Cibola Blanca and Cibola Roja, under the Staked Plains label.

Doc's son Kim McPherson, seen here in 1981, received a degree in food science from Texas Tech and completed winemaking studies at the University of California–Davis. He was hired as winemaker at Llano Estacado Winery in 1979 and helped lead the Texas effort to grow the classic vinifera grapes of Europe. (Courtesy of Ben Smusz.)

Bobby Cox, his wife, Jennifer, and his father, Charles Robert, started Pheasant Ridge Winery and estate vineyard. Texas wines had a breakout year in 1986. The Pheasant Ridge 1983 Cabernet Sauvignon won a gold medal, and the 1984 Llano Estacado Chardonnay won a double gold medal in the San Francisco Fair International Wine Competition. Bobby Cox and his father are seen here making wine in 1983. (Courtesy of Ben Smusz.)

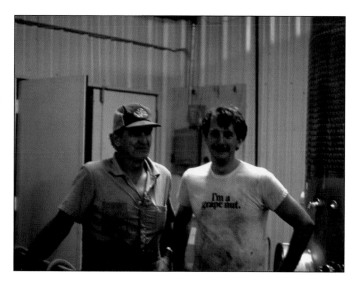

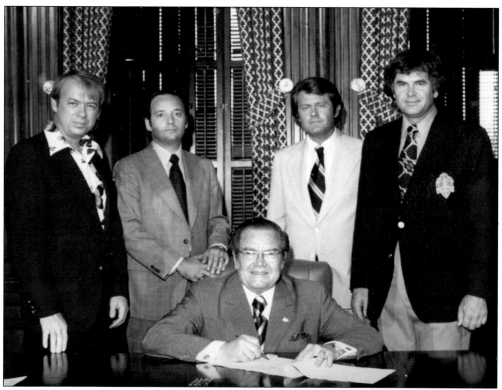

Many Texas wineries were in "dry" areas, where the sale of alcohol was not legal. Winery owners Dr. Bobby Smith of La Buena Vida (right) and Ed Auler of Fall Creek (second from right) worked with Texas legislator Bob McFarland (second from left) to get the Texas Farm Winery Act signed by Gov. Dolph Briscoe (center); on the left is Jim Cooper, Smith's pilot. This act allowed wine made in dry areas to be sold in "wet" areas, where the sale of alcohol was legal. (Courtesy Dr. Bobby Smith.)

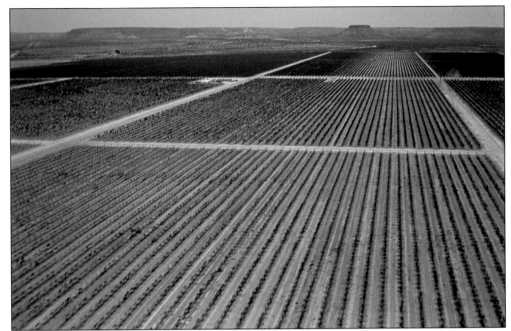

In the 1980s, University of Texas Lands, responsible for managing the permanent university lands and trust, started an investment outside of its historical areas of cattle, oil, and minerals. The investment involved the American-French Gill-Richter-Cordier joint venture, which included a 1,000-acre vineyard (shown in 1983) and the Ste. Genevieve Winery, with a capacity of over one million gallons. (Courtesy of M. Edwards, University of Texas.)

The size of the Ste. Genevieve project brought together people who have championed the modern Texas wine industry. Shown here are Charles McKinney (left) and Dr. Roy Mitchell in their wine laboratory in 1984. Their research in Texas viticulture and winemaking led to the large-scale UT Lands operation. This project gave a boost to the modern Texas wine industry. (Courtesy of William Stites.)

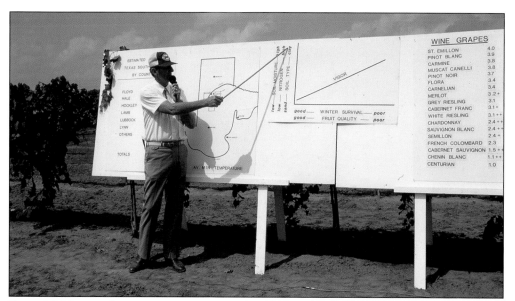

Texas A&M research on grape growing started in 1909, with a vineyard planted in Lubbock. But, this project was discontinued in the 1930s for lack of interest. William Lipe reestablished this important work in 1966, and it continued later under Dr. Ed Hellman. Lipe, shown here in 1987, is credited for having developed data on hundreds of grape varieties, rootstocks, and vineyard practices under local Texas conditions. (Courtesy of Ed Hellman.)

In 2001, the Texas Department of Agriculture (TDA) established the Texas Wine Marketing Assistance Program to increase awareness of Texas wines and to help benchmark their quality. Shown here are organizers of the 2010 Grape and Gridiron Classic, a friendly TDA-sponsored competition between Texas and New York wines. From Texas are wine writers Jeff Siegel (second from left) and Russ Kane (second from right); also pictured are Fred LeBrun (far left), Jim Trezine (center), and Richard Leahy (far right). (Courtesy of Jenny Gregorcyk.)

In 2005, a Texas Department of Agriculture program supported grape growing and winemaking through the Wine Industry Development Fund. It developed programs to address Pierce's disease in grapevines, wine quality, and other local concerns. Here, the Texas A&M Agrilife Extension viticulture and enology team poses for a photograph. They are, from left to right, Dr. Ed Hellman, Fran Pontasch, Mike Sipowicz, Fritz Westover, Dusty Timmons, and Penny Adams. (Courtesy of Fritz Westover.)

In 2003, promoting wine as a Texas agricultural product, an amendment to the Texas state constitution allowed sales of wine from wineries anywhere in the state no matter if dry, damp, or wet for alcohol sales. This milestone event led to a rapid increase in the number of wineries. Shown here is Sandstone Cellars, located in the "dry" hill country area in Mason County.

Two

TEXAS HILL COUNTRY

ITS PIONEERS

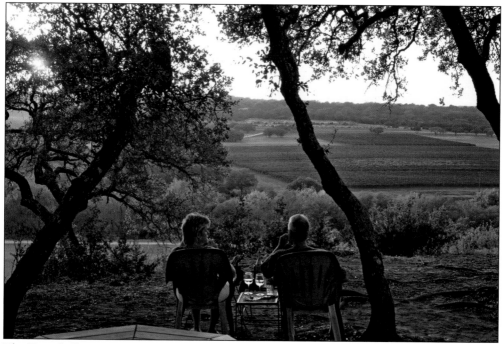

The Texas hill country was first described as a distinct region by Ferdinand Roemer, who traveled it from 1845 to 1847. This region, extending to the north and west of San Antonio and Austin, includes rocky ravines, slab limestone, sandstone outcrops, and arid, grass-covered prairies. It is the product of depositions of an inland sea with uplift and erosion. The features that Roemer described are evident at Driftwood Estate Vineyards (pictured) in Driftwood. The eye-appealing Driftwood Vineyards tasting room view overlooks its vineyard from a limestone bluff. The hill country's geologic features were produced over vast stretches of time, as were those in the famous wine regions of Europe. (Courtesy of Driftwood Vineyards.)

Texas is somewhat larger than France. This size comparison, along with major differences in climate and growing conditions, is important to the understanding of Texas wines and their diversity around the state. The Texas hill country is generally located in the central part of the state, in the uplifted region to the west of Interstate 35.

The Texas hill country contains three of the state's eight American Viticultural Areas (AVAs) as defined by the US government. Bell Mountain, the first AVA in Texas, was formed in 1986, followed by Fredericksburg in the Texas Hill Country in 1988 and the Texas Hill Country in 1991. The Texas Hill Country is the largest of the hill country AVAs, the second largest in Texas, and the forth largest in America.

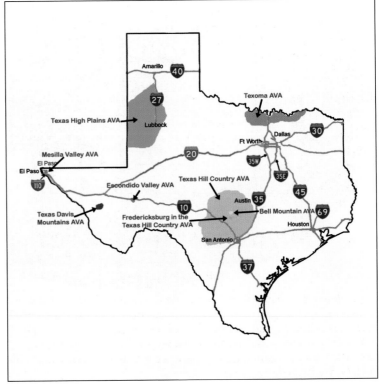

The Texas Hill Country AVA, the most extensively utilized hill country appellation, extends to 23 counties and consists of mostly clay loam, clay, and sandy clay loam—all useful for grape growing. The climate is varyingly subtropical and mostly arid, with cool winters and hot summers similar to southern Europe.

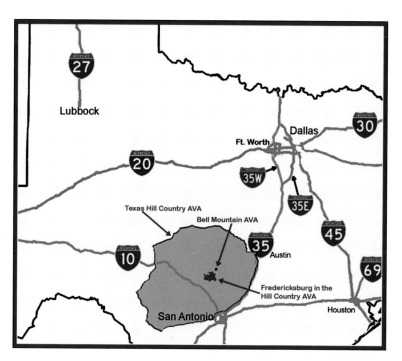

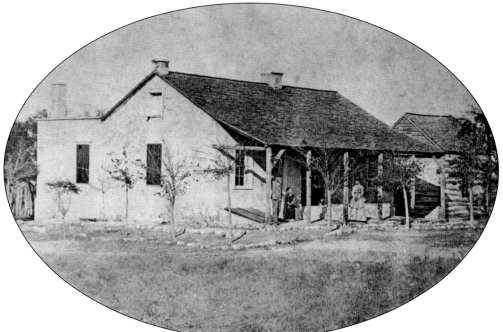

Luise Meusebach, daughter of Fredericksburg founder Baron Otfried Hans von Meusebach (later known in Texas as John O. Meusebach), married Wilhelm Marschall. They settled near Cherry Spring, north of Fredericksburg. Their home is shown here around 1875. Their family history indicates that wine was made from wild grapes that were "gathered in great wagons, crushed and fermented after measurements of sugar were added." (Courtesy of Gillespie County Historical Society, Fredericksburg, Texas.)

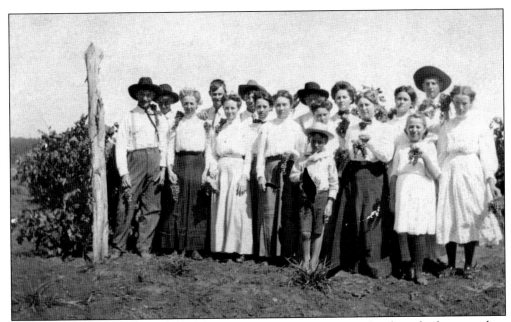

This photograph from the early 1900s shows members of the Lorenz family and others standing by cultivated grapevines on their property near Fredericksburg. It is harvest time, and everyone is holding ripe bunches of grapes. Grape harvesting was labor intensive and often involved the community. (Courtesy of Gillespie County Historical Society, Fredericksburg, Texas.)

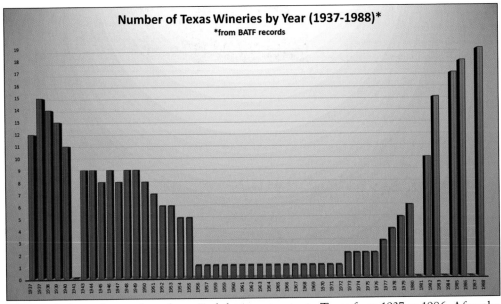

This graph shows the number of post-Prohibition wineries in Texas from 1937 to 1986. After the repeal of Prohibition, 12 Texas wineries were licensed in 1937. Early post-Prohibition hill country wineries were Sadorene Winery, Southern Winery, and Bonita Winery in San Antonio. Since much of Texas was dry in terms of the sale of alcohol, it was difficult to start and run wineries. This is evidenced by their decreasing numbers through the mid-1970s.

Ludwig Vorauer, a horticulturalist and emigrant from Austria, settled in Fredersickburg in 1913. He grew nut and fruit trees. Vorauer, seen here holding his bare-root pecan saplings, opened a nursery and a large vineyard. In 1937, his Texas Winery received Texas winery license No. 5. (Courtesy of Herbert and Joan Vorauer.)

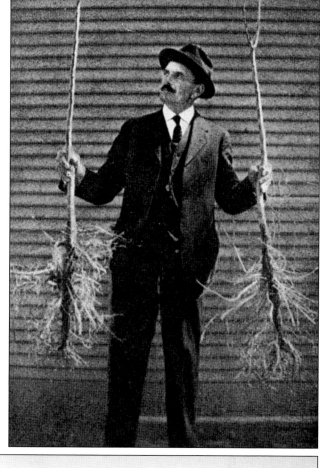

The Vorauer vineyard and farm included pecan orchards (right), various types of grapes (foreground), peach orchards (left), and other crops, including blackberries, plums, peas, and soybeans. A total of 25 acres of grapes were planted to support the Vorauer family's Texas Winery operation. (Courtesy of Herbert and Joan Vorauer.)

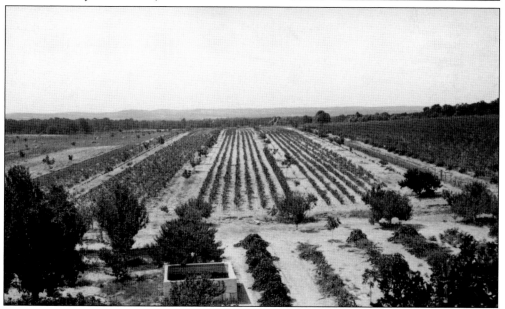

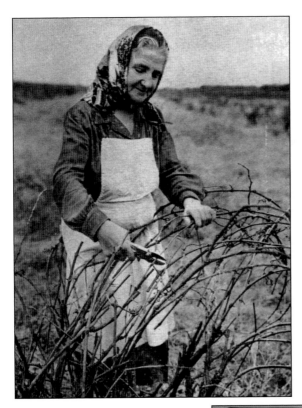

After Ludwig's death, his wife, Lina, and children ran the Texas Winery until 1955, when it closed. Lina Vorauer is shown here in 1951 pruning grapevines. Her grandson Michael Vorauer later became the winemaker at CapRock Winery (formerly Teysha Cellars) in Lubbock. (Courtesy of *San Antonio Express-News*.)

In 1975, the Haversack Wine Company opened near Frederickburg to much fanfare. Franciscan monks blessed the grapes, German music played, and Lady Bird Johnson planted the first grapevine. This venture commemorated Spanish missionaries who introduced the first wine culture to Texas 300 years prior. The winery was never federally licensed, and the venture came to an unsuccessful end.

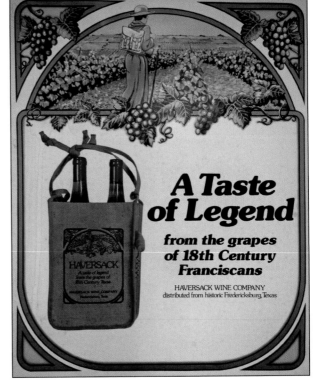

A Taste of Legend

from the grapes of 18th Century Franciscans

HAVERSACK WINE COMPANY
distributed from historic Fredericksburg, Texas

Ed Auler said, "Susan and I were on a trip to France to look at purchasing cattle. However, we spent most of the time going to French wineries. The land there reminded us of what we had in Texas on our Fall Creek ranch and gave us the vision to start Fall Creek Vineyards." Ed and Susan Auler (left) are seen here with friends Denman and Marijo Moody on a later trip to France in 1995. (Courtesy of Denman Moody.)

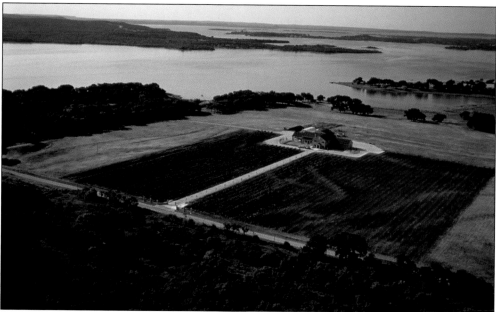

Starting in 1976, the Aulers planted an estate vineyard (shown here in 1983) on the shore of Lake Buchanan at their Fall Creek property in Tow, north of Fredericksburg. This location provided beneficial cooling breezes, but it also brought Pierce's disease, which for many years challenged Fall Creek and other hill country vineyards trying to grow European vinifera grapes. (Courtesy of Ben Smusz.)

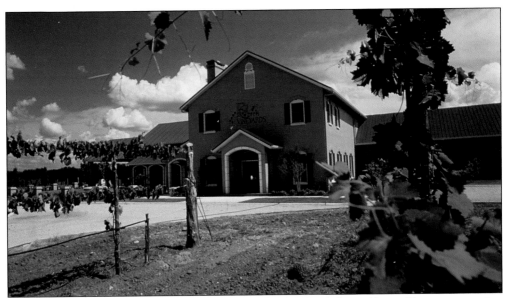

In 1983, the winery at Fall Creek Vineyards opened. Ed Auler dedicated himself to grape growing and winemaking. One of his advisors was Andre Tchelistcheff, one of California's foremost winemakers. Auler and Tchelistcheff both felt strongly that European vinifera grape varieties could make excellent wines in Texas. (Courtesy of Ben Smusz.)

Susan Auler, seen here at Dallas's Café Pacific, was one of the first to realize the natural connection between the evolving Texas wine and culinary scenes based on what she had experienced in Europe. Her efforts led to the Hill Country Wine & Food Festival and the establishment in 1985 of the Food & Wine Foundation of Texas. The foundation has contributed over $1 million in culinary grants and scholarships. (Courtesy of Fall Creek Vineyards.)

Robert Oberhelman, seen here in his estate vineyard, started what is one of oldest modern wineries in the Fredericksburg area. Robert and his wife, Evelyn, developed their estate vineyard in 1976, licensed their Bell Mountain Vineyards winery in 1983, and successfully obtained the first federal viticultural region in Texas (Bell Mountain AVA) in 1986. (Courtesy of Bell Mountain Vineyards.)

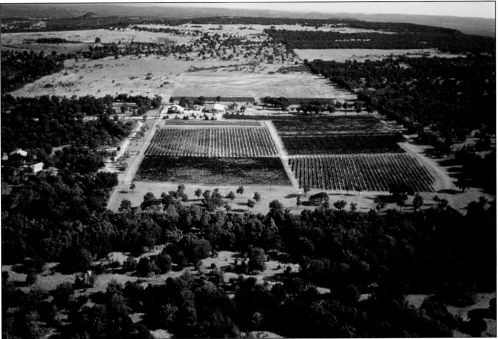

Robert Oberhelman's estate vineyard was located 14 miles north of Fredericksburg on the slope from Bell Mountain (shown here in 1983). He started by planting 25 varieties of grapes, including French American and American hybrids and European vinifera. Oberhelman soon settled on varieties such as Cabernet Sauvignon, Merlot, and Riesling that were well known to wine drinkers. (Courtesy of Ben Smusz.)

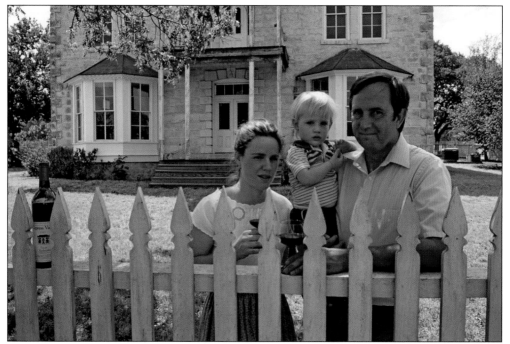

By the late 1970s, winemaking in the Texas hill country appeared to be viable. Unfortunately, not all efforts were successful. Dale Bettis worked with a horticultural student, Penny Adams, to plant vineyards in 1987, and they established Cypress Valley Winery in 1982. They also married and lived in the refurbished 1880s limestone Goeth House (pictured) in 1984 with their son Adam. (Courtesy of Penny Adams.)

Penny Adams studied enology and viticulture and obtained a degree from Fresno State University in California while doing her fieldwork in the vineyards and winery that she and Dale Bettis established back in Texas. While at Cypress Valley, Penny Adams became Texas's first professional female winemaker. (Courtesy of Penny Adams.)

In 1989, Dale Bettis passed away, but Penny Adams maintained her interest and career in Texas wine. She worked for other wineries, including Hill Country Cellars, seen here in 1991. She was also a Texas viticultural extension specialist and consultant. In 2010, Mike McHenry, owner of Wedding Oak Winery in San Saba, tapped Adams to be his winemaker. (Courtesy of Penny Adams.)

In 1985, Ned Simes planted his vineyard on a 17-acre plot next to Grape Creek. This was followed a couple years later with his Grape Creek Vineyards winery and tasting room. Simes's successful winery on this highly visible spot on Route 290 east of Fredericksburg promoted early winery tourism in the Texas hill country. (Courtesy of *Fredericksburg Standard Radio Post*.)

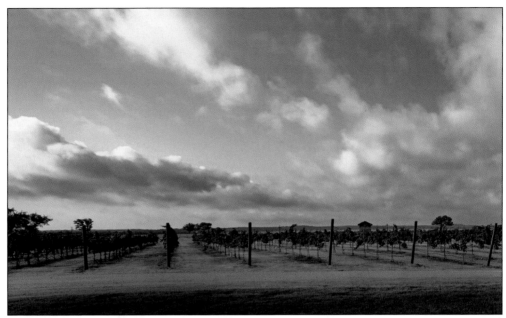

In 2004, Ned Simes passed away, and Grape Creek Vineyards was sold to Brian Heath, who reworked the vineyard, which had experienced difficulties with Pierce's disease (PD). Shown here is a view of Grape Creek's estate vineyard, which stands as a legacy to Ned Simes's hard work and new viticultural treatments and practices available to treat PD. (Courtesy of Grape Creek Vineyards.)

Dr. Richard and Bunny Becker were searching for a log cabin to renovate as a hill country getaway, and they were also entertaining thoughts of growing grapes. This photograph shows them in 1990 on the 46 acres of raw land they purchased in Stonewall. This became the site of Becker Vineyards. (Courtesy of Becker Vineyards.)

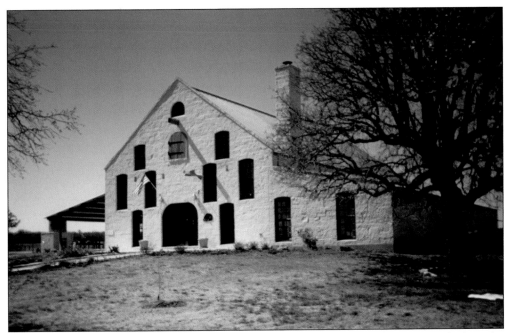

After establishing their vineyard, the Beckers opened their winery (pictured) in 1996, built in the traditional German hill country limestone block construction common to the area for over 100 years. The winery eventually expanded production to what is now about 100,000 cases per year, making it one of the largest premium wineries in Texas. (Courtesy of Becker Vineyards.)

Becker Vineyards has a 46-acre estate vineyard (pictured) and owns two additional vineyards near San Angelo and Mason, Texas, totaling about 90 acres. In addition, it contracts selectively from growers in the Texas hill country and high plains region near Lubbock for quality grapes composed of French, German, Spanish, and Italian varieties. (Courtesy of Becker Vineyards.)

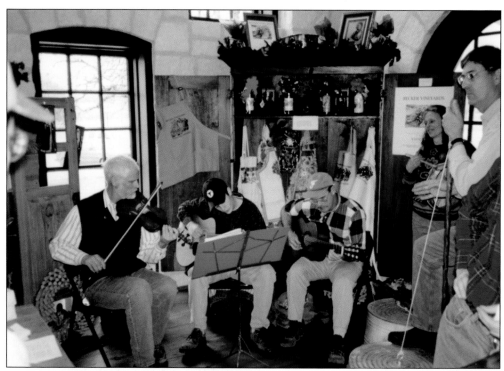

The Beckers have traveled to France, Italy, New Zealand, and Argentina to understand the latest winemaking techniques and to develop an international palate for wine and the culinary arts. The Beckers are also known for their friendly, down-home Texas manner. Here, Richard Becker sits in with his washtub bass with a band in his winery's tasting room. (Courtesy of Becker Vineyards.)

In 1999, a group of hill country wineries spearheaded by Gary and Kathy Gilstrap at Texas Hills Vineyard formed the association of wineries that created the first wine trail in Texas. Participating wineries offered special tastings, entertainment, and tours. This group has gone from 16 wineries in 2000 (seen in this poster) to nearly 50 wineries today. (Courtesy of Texas Hills Vineyard.)

Three

THE EASTERN HILL COUNTRY

THE BALCONES TRAIL

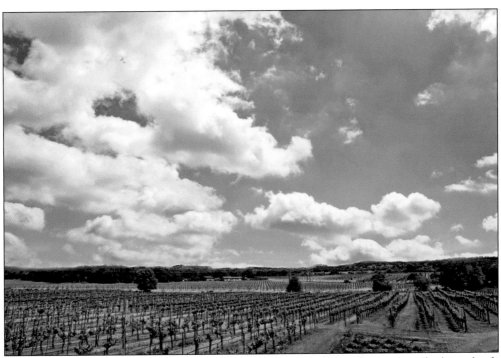

The Balcones Fault is the most significant land formation in Texas. It separates the lower lands to the south and east from the Texas highlands of the Edwards Plateau to its west. The Balcones Trail connects wineries from San Marcos and Wimberley northward through Dripping Springs and extending farther north, west of Austin, ending at Spicewood. There are expansive vineyards, dramatic sunsets, and scenic vistas, such as Spicewood Vineyards (pictured) on the southern shore of Lake Travis. This trail is the eastern entry to the Texas hill country and intersects the path of the immigrants to the region from Europe in the 1800s. (Courtesy of J.D. Swiger.)

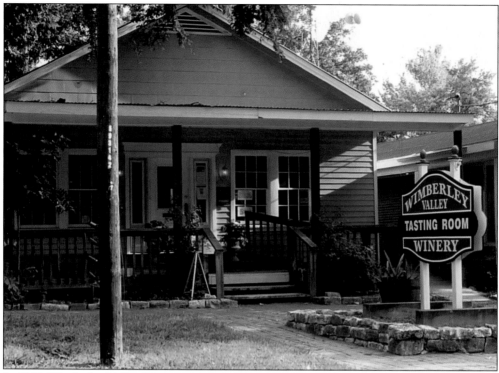

In 1983, Wimberley Valley Winery was started by Lee Hereford and winemaker Dean Valentine near Wimberley. When established, the winery was in an area that prohibited sales of alcohol until the 2000s. As such, the winery remained hidden from tourists, but it opened a tasting room (seen here in 2012) in Old Town Spring near Houston to sell its wines. (Courtesy of Jeff Cope, www.txwinelover.com.)

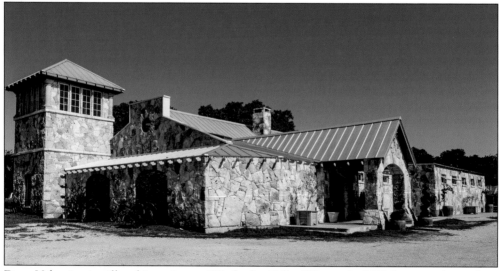

Dean Valentine is still making wines at Wimberley Valley Winery. In 2011, he opened a modern tasting room at that location and expanded the winery's fermenting and storage area. Its specialty is semisweet and sweet red, white (including Viognier and Moscato), and blush wines, along with seasonal fruit and Christmas wines. (Courtesy of James Skogsberg.)

Driftwood Vineyards is acknowledged by many to have the best tasting-room view in the hill country. It overlooks an estate vineyard from a bluff (pictured). The vineyard was begun in 2002 by Gary Elliot, an ex–Continental Airlines pilot who had tried several other agricultural uses for the family's land before finding success with grapes. (Courtesy of Driftwood Vineyards.)

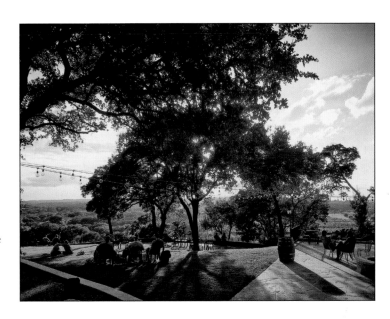

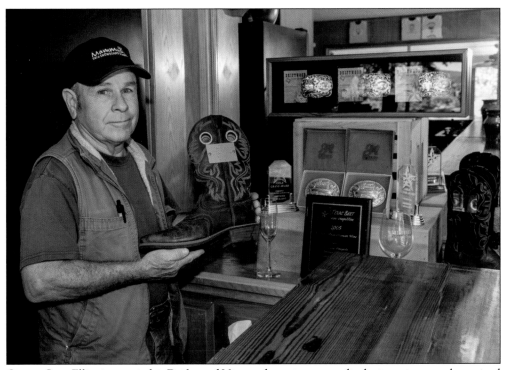

Owner Gary Elliot is seen in his Driftwood Vineyards tasting room, displaying wine awards received in state, national, and international competitions. He holds his prized "boot," awarded by the Lone Star International Wine Competition for his 2006 Estate Lone Star Cabernet Sauvignon, named the Grand Star (Double Gold Medal) award winner. (Courtesy of James Skogsberg.)

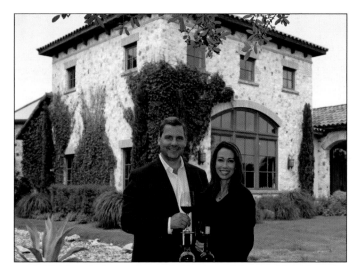

Stan and Lisa Duchman, owners of Duchman Family Winery, stand in front of their winery, constructed in Italian villa style. This design is appropriate, as the Duchmans feature Italian-style wines from grapes grown in Texas. They include white wines like Viognier, Moscato, and their widely acclaimed Vermentino. Reds include Montepulciano, Sangiovese, Dolcetto, and Aglianico. (Courtesy of Duchman Family Winery.)

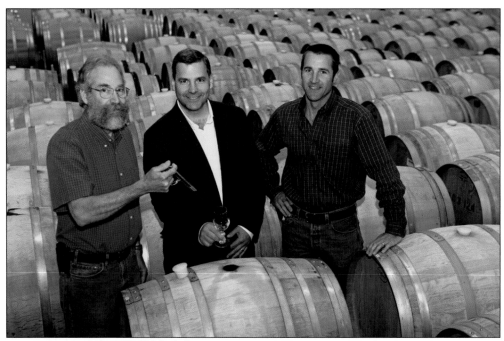

Duchman Family Winery started in 2004, with Mark Penna as winemaker before his passing in 2011. Penna (left) is seen here with owner Stan Duchman (center) and apprentice, now winemaker, Dave Reilly. Penna's roots went back to the Texas wine industry's early days. His vision was that Texas's warm climate would be better for Italian grapes than for more conventional French varieties. (Courtesy of Duchman Family Winery.)

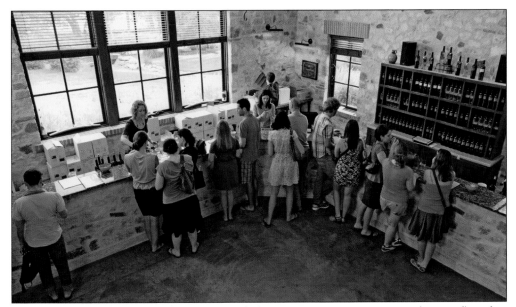

The venue at Duchman Family Winery includes an engaging tasting room (pictured) with a windowed view into the barrel room, fermentation tanks, and a production area a short walk away. There are also outdoor areas in the shade of the oaks on the winery grounds. (Courtesy of Duchman Family Winery.)

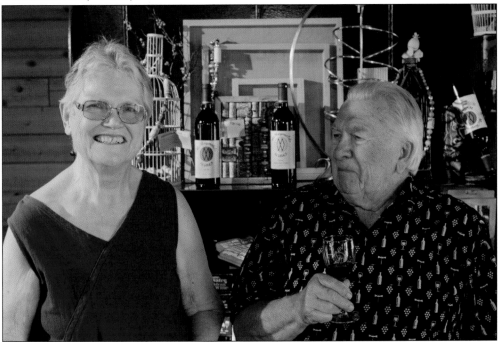

In the early 1970s, Maureen and Mac McReynolds began their winemaking careers part-time while living in California. In 1989, they purchased five acres in the Texas hill country, including a small house and a large metal frame building that had formerly housed a winery. In 2000, with Mac's fondness for juicy red Syrah, the happy couple opened their log-cabin tasting room at McReynolds Wines. (Courtesy of James Skogsberg.)

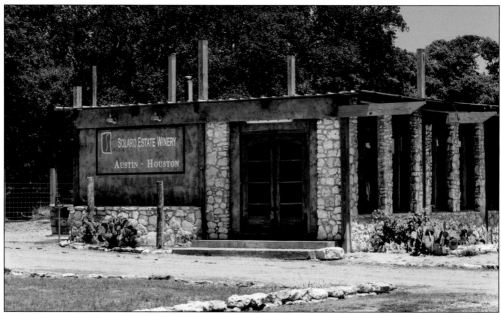

The Solaro Estate Winery near Dripping Springs resides on the Fritz family property, owned since the early 1900s, near Barton Creek. There, Barbara Haderlein and partner Robert Fritz created an estate vineyard, winery, and tasting pavilion (pictured), accompanied by Thoroughbreds and Angus cattle. The vineyard was planted starting in 2002, and the winery operations were under way in 2009. (Courtesy of James Skogsberg.)

The wines at Solaro Estate include those from the estate vineyard made from Italian grape varieties, Barbera and Montepulciano. The winery has also been successful making other Texas appellation wines from Texas Hill Country and Texas High Plains grapes. In 2014, Haderlein and Fritz opened Solaro Urban Winery (pictured) in Houston's midtown. (Courtesy of Solaro Estate Winery.)

Bell Springs Winery was opened in 2010 by owner and winemaker Nate Pruitt. He says, "The winery was built with both Texas friendly and modern casual in mind." It is a place where people can meet, relax, unpretentiously sip wine, and listen to music on the back patio. Live music is performed on weekends. (Courtesy of Bell Springs Winery.)

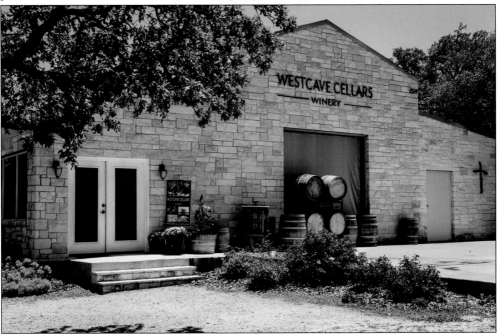

West Cave Cellars, built in 2010 and located in Round Mountain, crafts traditional-styled wines from Texas grapes. Estate wines and blends include Vermentino, Muscat Blanc, Viognier, Petite Syrah, Cabernet Sauvignon, and Tannat. Other wines are made from grapes of other Texas vineyards. (Courtesy of James Skogsberg.)

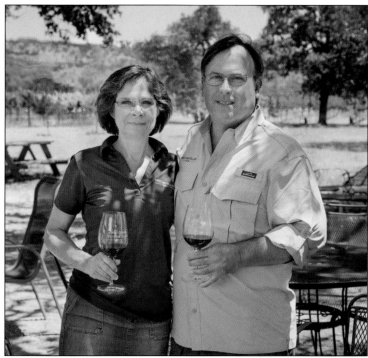

West Cave Cellars owners Allan and Margaret Fetty started with a vegetable garden and an evening glass of wine. The garden grew into a test plot of vines, and a new lifestyle began. In 1999, they planted three acres of grapes, selling to local wineries. The Fettys then increased their vineyard and built their winery, where they combine interests in wine, music, cars, art, and everything else. (Courtesy of James Skogsberg.)

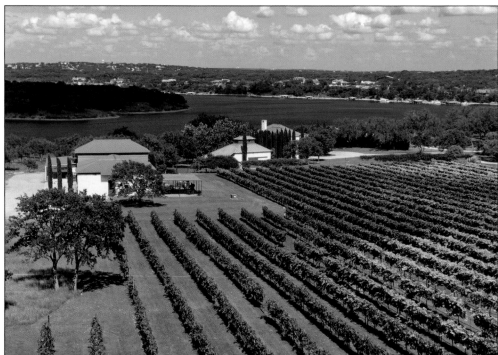

Angela Moench started buying several acres of land bordering Lake Travis in the Texas hill country and followed this by planting Norton vines in 2000. From experience in Missouri, she knew Norton made big red wines and was disease-resistant. The block-limestone winery and tasting room are adjacent to the Stone House Vineyard. (Courtesy of Stone House Vineyard.)

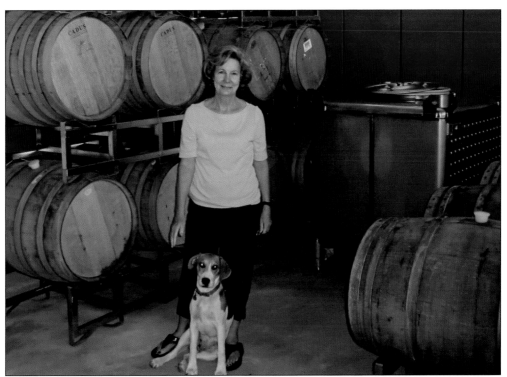

In 2004, Moench released her first wine, Claros, which won a Gold Medal and Best of Class in the Pacific Rim International Wine Competition. Then came the release of a Port wine, Scheming Beagle, also made from Norton. Moench is seen here with that wine's namesake, her beagle Schopenhauer. (Courtesy of Stone House Vineyard.)

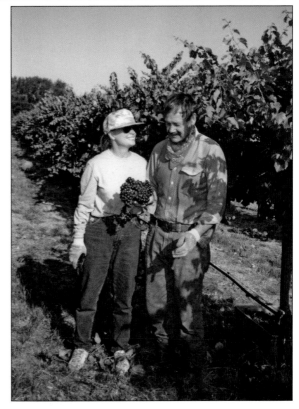

Originally in a dry area for sales of alcohol near the south shore of Lake Travis, Spicewood Vineyards was founded in 1992 by Edward and Madeleine Manigold. Their successes with Sauvignon Blanc, Semillon, and Chardonnay from their estate vineyard were their crowning achievements. (Courtesy of Edward and Madeleine Manigold.)

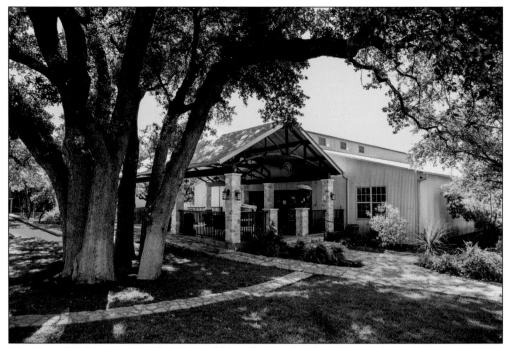

The Yates family continues the Manigolds' tradition of making fine and award-winning wines. The winery is contiguous with the original building (shown here). It serves as the tasting and sales room (no longer in a dry area) and an event venue. The winery building is approximately 5,000 square feet on two levels, including a limestone cellar. (Courtesy of James Skogsberg.)

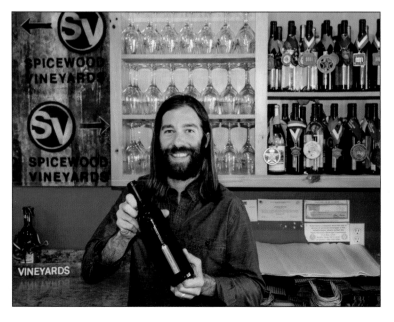

Ron Yates, president of Spicewood Vineyards, shows his Estate Tempranillo. Yates has expanded production into warm-weather varieties of grapes from Spain, Portugal, France, and Italy, grown in Texas. He features Viognier, Roussanne for white wines, Tempranillo, and Touriga Nacional for reds and other varieties, too. (Courtesy of James Skogsberg.)

Four

THE HEART
OF THE HILL COUNTRY
THE ROUTE 290 TRAIL

It seems that all hill country roads lead to Fredericksburg, the city that welcomes all wine visitors to the region. Fredericksburg is literally at both the epicenter of the Texas hill country wine movement and in the middle of Fredericksburg in the Texas Hill Country and the Texas Hill Country viticultural areas. The major artery flowing east and west through this region is Route 290. As Route 29 through Napa and Yountville in California is known for its density of Napa Valley wineries, Route 290 has the highest density of wineries anywhere in Texas. Commonly referred to as the "290 Wine Road," this trail extends from Fredericksburg on the west through Hye and on to Johnson City on the east.

Fredericksburg Winery in downtown Fredericksburg was started in 1996. It is a family winery. Brothers Cord, Gene (now deceased), and Bert Switzer worked with their wives and families, including Gene's daughter Chardonnay and Oma (now deceased), in their shopping center location. A visitor will not see any grapevines out back; not to worry, this Swiss family purchases grapes from vineyards all around Texas. (Courtesy of James Skogsberg.)

Cord Switzer stands in the Fredericksburg Winery tasting room, where he welcomes visitors most days. He offers a range of dry, semidry whites and reds, and sweet to very sweet wines (up to 15 percent residual sugar). The rule of the tasting room is to always taste wines in order of increasing sweetness, or else! (Courtesy of James Skogsberg.)

Fiesta Winery offers two colorful tasting rooms, one in Fredericksburg and one just outside of town, east on Route 290. Its winery is in Lometa in the northern hill country. Fiesta offers wines made for sipping, with a number of sweet wines, but it also offers the serious wine drinker Tempranillo, Merlot, and Cabernet. (Courtesy of James Skogsberg.)

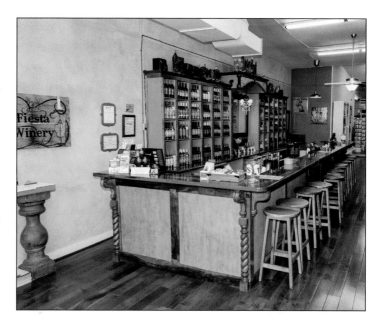

Roberto Ponte stands in his Rancho Ponte Vineyard tasting room east of Fredericksburg. He comes from a long line of winemakers, back to his great-grandfather Luigi in the Friuli region of Italy. Roberto and his wife, Rachel, came to Texas from California, where his family grows grapes and makes wine. He offers a range of wines and has recently started an estate vineyard. (Courtesy of James Skogsberg.)

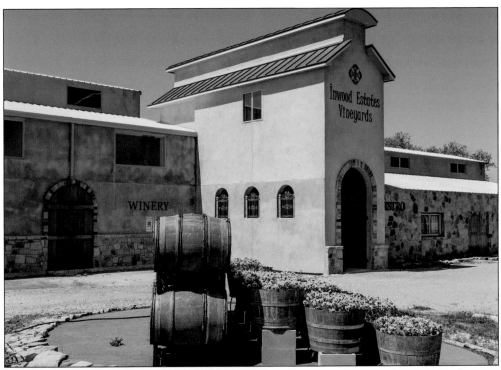

Owner and winemaker Dan Gatlin and his wife, Rose Mary, added this boutique winery, tasting room, and bistro on Route 290 to their assemblage of winery operations, including Fredericksburg, the Vineyard at Florence, and central Dallas locations. Visitors can sample his wines and savor delicious baby back ribs and pulled pork in the bistro or just sit on the patio with wine and relax. (Courtesy of James Skogsberg.)

Inwood's Dan Gatlin (shown here at Austin's Red Room), who is as complex as his wines, has championed both Texas terroir and Spanish grapes grown in Texas. His wines are found in many of the top Texas restaurants. Starting in 1981, his passion and years of trial and error led him to Neal Newsom's high plains vineyard in Plains, near Lubbock. The location, at over 3,500 feet, was where they ventured to make the first vineyard planting of Texas Tempranillo. (Courtesy of Matt McGinnis, whatareyoudrinking.net.)

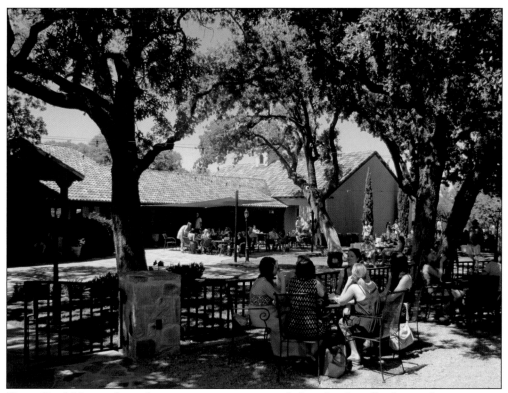

Grape Creek Vineyards is a destination winery, an oasis sheltered under tall oak trees. Its appropriate moniker is "Tuscany in Texas," reflected in its romantic Italian villa architecture. Patrons can taste wine in the tasting room or ease themselves down in the shade under the oaks. Wine club members can visit with friends in the "members only" pavilion.

Winemaker Jason Englert (left), after eight years at Llano Estacado Winery, and Grape Creek owner Brian Heath (right) work together to provide the complete wine country experience. They offer quality wines in a wide variety of styles and blends, especially Italian. (Courtesy of Grape Creek Vineyards.)

Grape Creek Vineyards offers multiple tasting venues, including the newly designed Ambassador tasting room (shown) that looks out into the vineyard from the ground floor of the original winery building, erected in the 1980s. Tasting rooms are in downtown Fredericksburg and Georgetown.

Ken and Janise Maxwell started Torre di Pietra (Tower of Stone) after working in the high-tech sector. Janise's family legacy stretches to the interior of Mexico in the early days of Spanish exploration of the American southwest. A 1755 census shows that her ancestors owned vineyards in what today is Socorro, Texas. (Courtesy of Torre di Pietra.)

Torre di Pietra derives its name from the impressive stonework used on the winery, harkening back to Italian origins. The winery makes wine from its European vinifera and hybrids (Black Spanish and Blanc Du Bois). It offers indoor and outdoor tasting and entertainment venues. Its main tasting room provides a softly lit ambiance that envelops its visitors. (Courtesy of Torre di Pietra.)

4.0 Cellars is an alliance of three Texas wineries: Brennan Vineyards, Lost Oak Winery, and McPherson Cellars. These wineries are located in more remote Texas areas: Comanche, Burleson, and Lubbock, respectively. The contemporary outpost winery and tasting room shown here, near Fredericksburg, combines the draw of the Texas hill country with premium Texas wineries. (Courtesy of James Skogsberg.)

The three husband-wife partners from the 4.0 Cellars wineries, shown here at the 2014 Buffalo Gap Wine & Food Summit, extend their invitation to visitors. They are, from left to right, Judy and Gene Estes (Lost Oak Winery), Pat and Trelise Brennan (Brennan Vineyards), and Kim and Sylvia McPherson (McPherson Cellars).

4.0 Cellars, with its modern, open architecture, interior styling, and outdoor picnic and event areas, is something one would expect to see in California. But, it is a delightful surprise in central Texas. The ability to taste wines from three different premium wineries is an added benefit. (Courtesy of James Skogsberg.)

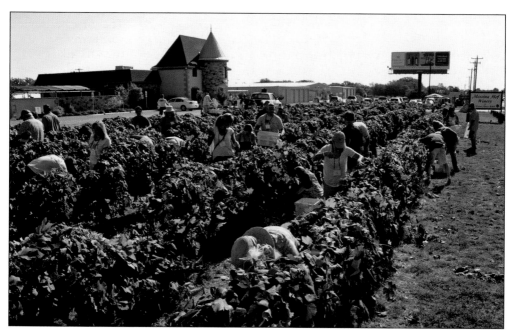

Messina Hof Winery, a long-standing wine brand in Texas, was started by Paul and Merrill Bonarrigo in Bryan in 1983. They planted their first vineyard in 1977. In 2011, they opened Messina Hof Hill Country Winery on Route 290. The Messina Hof harvest event shown here includes picking and stomping grapes, live music, and food. (Courtesy of Messina Hof Winery.)

Messina Hof became a multigenerational winery when founders Paul and Merrill Bonarrigo's son Paul Mitchell and his wife, Karen, joined them. Visitors are welcome to sample Messina Hof's broad range of wines, from its dry reds and whites, semi-sweet, rosés, and blush wines, to its legendary Port and its Premium Paulo series. Visitors are invited to stay in the Manor Haus bed-and-breakfast. (Courtesy James Skogsberg.)

Becker Vineyards helped establish the reputation and visitor experience of the hill country wineries. The winery facilities (pictured) have expanded over the years since its inception. Wine from Becker Vineyards has been served at presidential dinners at the White House and has been featured at the renowned James Beard House in New York. (Courtesy of Becker Vineyards.)

The large wood-paneled tasting room at Becker Vineyards is always a festive location to explore wines. It is complemented by the stately Lavender Haus Reception Hall and a Provence-like wedding venue, with an expansive lavender field behind the winery. (Courtesy of James Skogsberg.)

Since 1999, Woodrose Winery owner Mike Guilette has welcomed visitors on his 24-acre estate east of Fredericksburg. The dance hall–styled event center and its shaded wraparound porch await visitors. Guilette's award-winning new-world Tempranillo and blends are noteworthy. As demonstrated by Robin Danz, tastings are done at individual tables in red, white, sweet, and mixed flights. (Courtesy James Skogsberg.)

As winery owner Erik Hilmy admitted, "What started as a personal hobby is now, happily, a thriving new winery." Erik, self-taught and a bit mysterious to some, makes wines that are inviting and that call for a stop in his tasting room. There, a visitor may meet his wife Hildy, chickens, a rooster, and some mighty big (but friendly) dogs. (Courtesy of James Skogsberg.)

The dream that became Pedernales Cellars started in the 1990s with the planting of a hill country vineyard by Larry Kuhlken (pictured) and his wife Jeannie, children David and Julie, and David's wife Heather. The facility is dedicated to world-class wines with sustainable practices. (Courtesy of Pedernales Cellars.)

Pedernales Cellars, with its winery and tasting room near Stonewall, has turned heads internationally with Texas Tempranillo and Viognier. Winemaker David Kuhlken also works with Touriga Nacional, Albariño, Grenache from the Kuhlken Estate, and with grapes from the Texas high plains. (Courtesy of James Skogsberg.)

Pedernales Cellars owners Julie Kuhlken and her husband, Fredrik Osterberg, are shown with their award-winning Tempranillo and the saddle they won for their 2012 Viognier, awarded the Best Texas Wine at the 2013 Houston Livestock Show and Rodeo International Wine Competition. (Courtesy of James Skogsberg.)

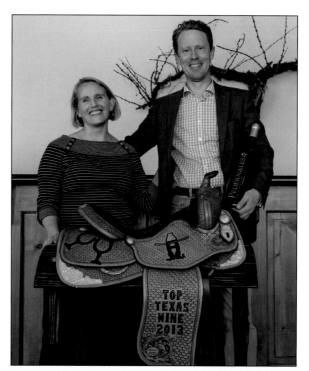

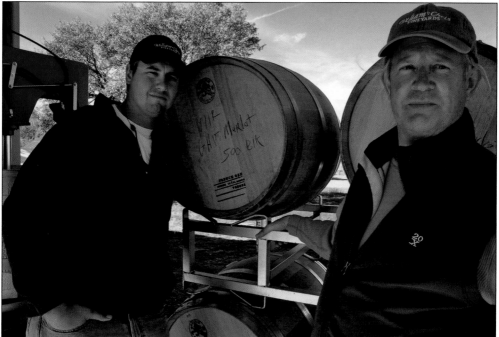

At William Chris Vineyards in Hye, William Blackmon (right), with long experience in Texas wine, and Chris Brundrett (left), a fast-rising young winemaker, are philosophers of wine. They trust each to come into its own with little intervention. They make wines that are balanced, not over extracted; they are often blends that emphasize aroma and flavor. (Courtesy of Miguel Lecuona, Wine Marketing Guide LLC.)

Blackmon and Brundrett bottled their first vintage together at William Chris Vineyards in 2008. Their tasting room, started in a 100-year-old farmhouse next to a 1800s cemetery, now has a fresh look with an addition to the back (pictured). More room and more wines make for more fun for their "Hye Society" visitors.

For "Friends in Hye Places," check out Hye Meadow Winery partners Chris Black (left), Jeff Ivy (center), and Mike Batek. The winery opened in 2013, and winemaker Ivy makes wines that express where they were grown. Due to a shortage of Texas grapes, some have expressed Texas, but others New Mexico and Washington State. All are correctly and proudly labeled. (Courtesy of James Skogsberg.)

Lewis Wines near Johnson City focuses on Mediterranean varieties; wines are available for tasting by appointment. Shown here are, from left to right, co-owners Doug Lewis and Duncan McNabb, with Kyle Gholson, Jorge Ruelas, and Rob Reynolds. They take wine seriously, using hand craftsmanship and careful aging. They are planting on their estate and use grapes from other Texas vineyards. (Courtesy of James Skogsberg.)

Gary Gilstrap is seen here in the tasting room of his Texas Hills Vineyard near Johnson City. He and his wife, Kathy, started looking for hill country land in 1993. They are credited as champions of the Texas hill country wine trail from its inception about 15 years ago.

At Texas Hills Vineyard, the Gilstraps started planting their 25-acre estate vineyard in 1995, with a focus on Italian varieties. Their labor of love was done the old-fashioned way, starting with family, friends, and hand tools. When those failed to break the hard-packed clay loam soil, a tractor with an auger was their savior. (Courtesy of Texas Hills Vineyard.)

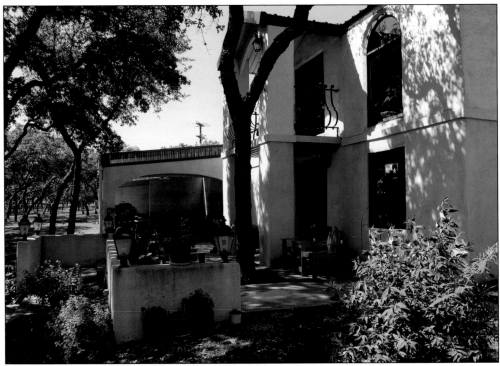

The winery at Texas Hills Vineyard, according to Gary Gilstrap, "was built like an Igloo cooler." Its thick concrete walls, created with a void space in the middle, were cast in the form of an Italian villa. The winery is unique for its lack of oak barrels, allowing Gilstrap to meter oak alternatives and for micro-oxygenation, giving his wines the lean tannic "Italian Style" he likes. (Courtesy of Texas Hills Vineyard.)

Five

THE NORTHERN HILL COUNTRY

THE COLORADO RIVER TRAIL

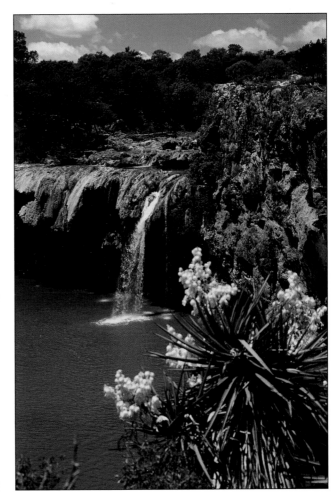

The Colorado River was named by Spanish settlers for its ruddy color. This river is the boundary that central Texans use to define the upper regions of the Texas hill country. Ed Auler, of Fall Creek Vineyards, who crafted the Texas Hill Country AVA, said, "The Colorado River is the boundary between what most of us know as the Texas hill country and the 'just-hilly-country' to the north." This wine trail starts near Marble Falls and meanders through Burnet, Lampasses, San Saba, and the western shore of Lake Buchanan. The wineries in this region offer a backwoods experience, but the winemaking is some of the best in the state. The venues surprise with their refined elegance or simple comfort. The falls at Fall Creek on Ed and Suan Auler's family estate (pictured) gives their winery its name. (Courtesy of Ben Smusz.)

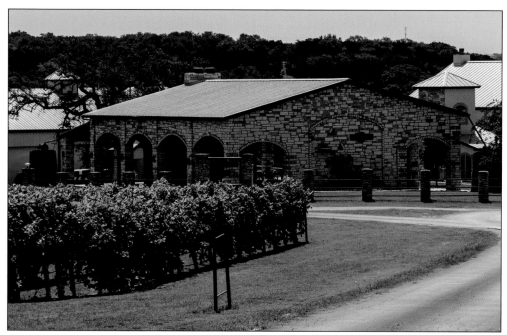

Flat Creek Estate owners Rick and Madelyn Naber started their venture to create a picture-book winery and estate vineyard set amid the beautiful rolling hills on the north shore of Lake Travis near Marble Falls. Since 2000, the vineyard has increased from 6 acres to over 20 acres; the winery was completed in 2001. (Courtesy of James Skogsberg.)

At Flat Creek, it all started with a Grand Planting Day. With the help of 60 guests, the Nabors planted 6,000 vines in just six hours. These vines now contribute Sangiovese for Flat Creek's "Super Texan" and Tinta Madeira for its estate Port-style wine. (Courtesy of Flat Creek Estate.)

The tasting room at Flat Creek Estate features views of the vineyards and offers wines comprised of grape varieties originating from Italy, Portugal, and the Rhone Valley in southern France. Many are harvested from the same vineyard that can be viewed from this tasting room. Flat Creek also features an event center, bistro, and an *enoteca* with wood-fired pizzas and artisan cheeses. (Courtesy of James Skogsberg.)

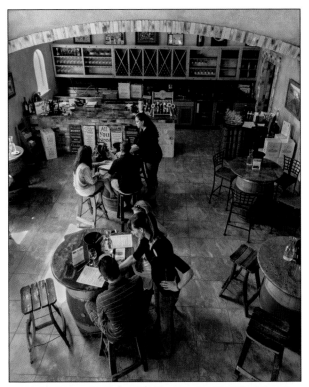

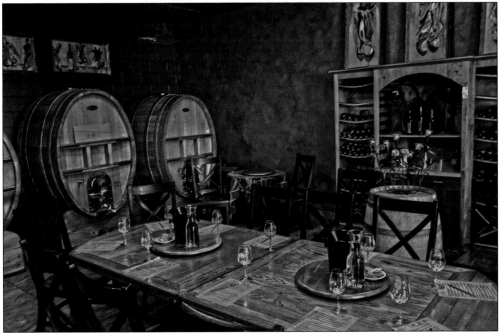

For those looking for an intimate tasting or in need of a venue for a small event, Flat Creek Estate has just the setting: this barrel room converted to an event room. The room is softly lit and is warm with ambiance. It is a great place to relax from the heat of the Texas summer or to savor a special moment. (Courtesy of James Skogsberg.)

Seth and Laura Martin not only grow grapes and make wine on their estate, but they also live and homeschool their children there. In many ways, it is a throwback to the old Texas family farms from the 1800s, many of which made wine. The name of their winery, Perissos, is a Greek word in the Bible (Ephesians 3:20) meaning "exceeding abundantly"—and this is their mission. (Courtesy of Sandy Wilson Photography.)

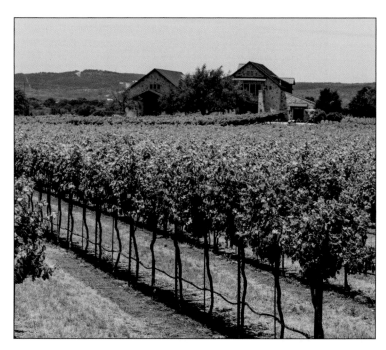

A visitor upon entering Perissos Vineyard encounters a sea of green vines: 16 acres of Aglianico, Tempranillo, Muscat, Viognier, Syrah, and Petite Sirah, including a test block with other Italian, French, Portuguese, and Argentinean varieties. In back is the two-story winery that includes the Martin family homestead. (Courtesy of James Skogsberg.)

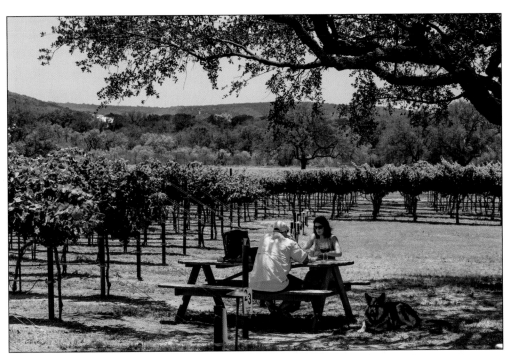

The Perissos estate is the place for a lunchtime or late-afternoon picnic while sampling Perissos Vineyard wines. All are 100 percent Texas grown and feature varieties that may be new to some: Aglianico, a red grape commonly found in southern Italy, and Viognier and Roussanne, white grapes indigenous to southern France. (Courtesy of James Skogsberg.)

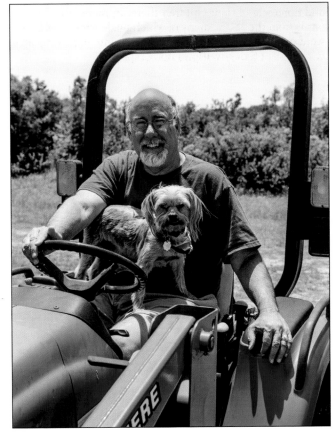

Bill Bledsoe and his wife, Sulynn, started Texas Legato Winery on the outskirts of Lampasas. Visitors may find Bill on his tractor in the vineyard, perhaps with his furry friend (pictured). Bill's twin brother, Gill, owns another winery less than a mile away. To tell Bill from Gill, one needs to keep in mind that Bill has the beard. (Courtesy of James Skogsberg.)

Legato is Italian for "coming together," as with family or friends. Those looking to escape the big city might find others hoping to do the same at Texas Legato. Patrons can enjoy Cabernet, Malbec, and several other of Bill Bledsoe's dry wines or sit a spell and have a sip of sweetness. (Courtesy of James Skogsberg.)

Literally around the corner from Texas Legato, or a short hike across the vineyard, is Pillar Bluff vineyards, owned by Bill Bledsoe's twin brother, Gill, and his wife, Peggy. The Pillar Bluff gazebo, with its vineyard view, is inviting. The tasting room features small production wines and a bit of tongue-in-cheek Bledsoe humor in his "BoarDoe," a classic red Bordeaux blend (right).

To the west is Lometa and Fiesta Winery, owned by Stephen and Sally Baxter. As seen in their Fredericksburg tasting rooms, they show a flair for bright American southwestern colors and catchy names. Visitors can try their seriously good dry wines or have their laid-back Back Porch Sittin' sweet red or Skinny Dippin' sweet white. (Courtesy of James Skogsberag.)

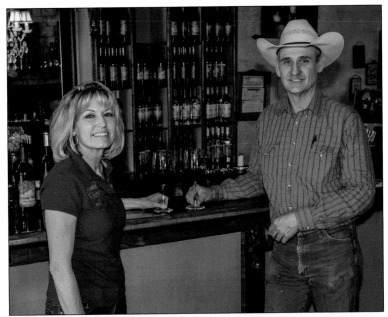

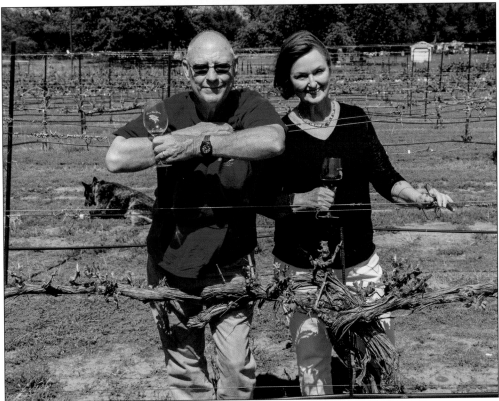

Like most fine wines anywhere, the quality comes from the vineyard. Alamosa Wine Cellars owners Jim and Karen Johnson set up their vineyard in Bend in 1996. At the time, the Johnsons had the only venture in Texas dedicated exclusively to growing warm-climate grapes with Mediterranean origin. (Courtesy of James Skogsberg.)

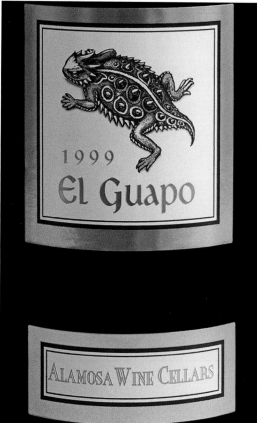

Before Alamosa, Jim Johnson lived in Texas, studied at the University of California at Davis, had stints at California wineries like Heitz Cellars, and plied his skills at other Texas wineries. Then, Jim and Karen bonded their Alamosa Wine Cellars winery in 1999 and worked hand-in-hand. (Courtesy of James Skogsberg.)

In 1999, Alamosa Wine Cellars produced the first commercial Tempranillo wine in Texas. Knowing that Tempranillo had almost no name recognition at the time, Johnson called it simply "El Guapo." In 2002, *Wine Spectator* proclaimed that Johnson was a "guide to the future" of Texas wine and acclaimed him the "very soul of winemaking" in Texas. (Courtesy of Trish Fullerton.)

In a historical building in old San Saba, Wedding Oak Winery strikes an image of the rural Texas renaissance. The ruins of the 18th-century Mission Santa Cruz de San Saba are not far away, and San Saba is steeped in history and tradition. This is where Mike and Lynn McHenry (pictured) opened their winery in 2012. (Courtesy of Jeff Cope, www.txwinelover.com.)

The charm of Wedding Oak Winery's tasting room is appreciated immediately. It has been called an "oasis in the middle of central Texas" by visitors. The McHenrys, and longtime Texas winemaker Penny Adams, are working with a combination of single varietal wines and blends to maintain 100-percent Texas grapes, sourced from hill country and high plains vineyards. (Courtesy of Wedding Oak Winery.)

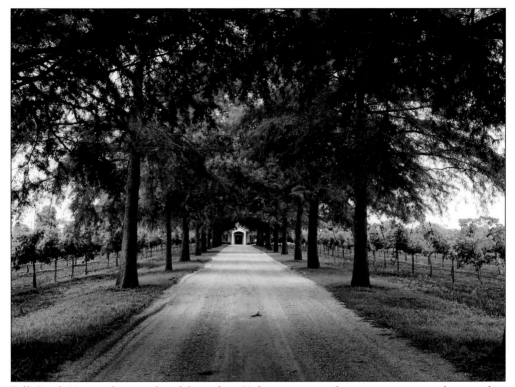

Fall Creek Vineyards recently celebrated its 30th anniversary, but, as its entrance shows, it has the elegance and charm of age-old wineries found in leading international wine regions. It has relentlessly led the way to the boom that the Texas wine industry is experiencing today. Fall Creek offers fine wines, wine experiences, and events.

In 2013, Fall Creek Vineyards owners Ed and Susan Auler made a bold move by hiring a talented international winemaker, Sergio Cuadra, from Chile to lead their winery into the future. In less than a year, Cuadra (shown here with Susan Auler), with his global perspectives, championed a new red GSM blend (Grenache, Syrah, and Mourvèdre) for the winery and obtained a double gold for his Fall Creek Texas Sauvignon Blanc.

Six

THE SOUTHERN
HILL COUNTRY
THE GUADALUPE RIVER TRAIL

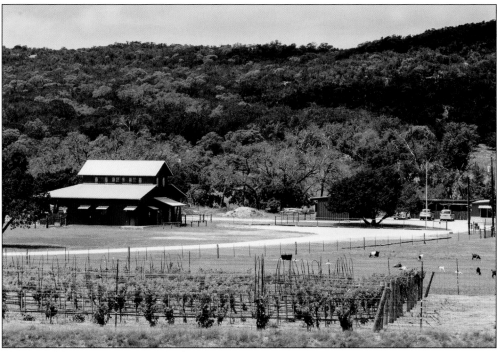

The Guadalupe River is a popular hill country destination for rafting, fly-fishing, canoeing, and now for wine tasting. This trail heads southward from Fredericksburg to Kerrville, through Comfort and Sisterdale, and ending up at New Braunfels on Interstate 35. The river was originally named Nuestra Señora de Guadalupe by Alonso de León in the Spanish settlement period. San Antonio, now the seventh-largest city in America, is sending its tendrils out to meet this trail. While still only mildly populated with wineries, this trail has some gems, mostly boutique wineries. Some have estate vineyards, such as Singing Water Vineyards (pictured), offering their own brand of hospitality, while others are pushing the forefront of fermentation science. There are fine wine experiences along the restful banks of the Guadalupe River. (Courtesy of James Skogsberg.)

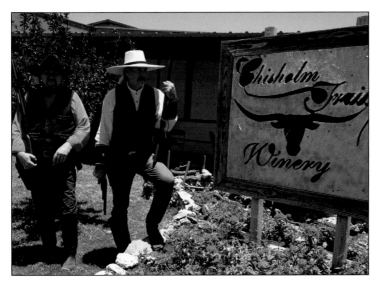

Chisholm Trail Winery, located west of Fredericksburg on Route 290, released its first wines in 2001. Owner and winemaker Paula Williamson, who named the winery in honor of the Chisholm Trail of Texas cattle-drive fame, links her winery's motif with that point in Texas history. (Courtesy of Miguel Lecuona, Wine Marketing Guide LLC.)

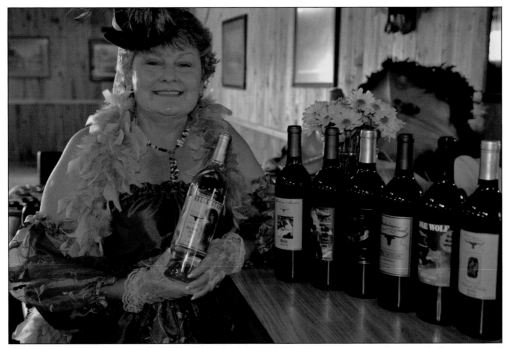

Paula Williamson (pictured) and her Chisholm Trail Winery associates often get fully immersed in the cowboy theme, down to their wardrobes. Join the fun and sample award-winning wines with very appropriate names like High Noon, Desperado, Lil's Red Satin Cabernet Sauvignon, and Ghost Rider. (Courtesy of Miguel Lecuona, Wine Marketing Guide LLC.)

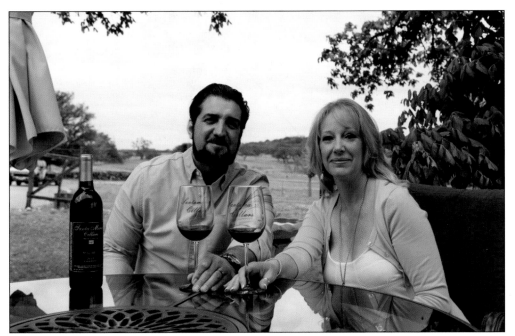

Near Kerrville is a small, quality producer of wines, Santa Maria Cellars. Owner and winemaker Martin Santamaria originates from the Argentine wine region of Mendoza and has mastered the art of winemaking in Texas while adding his own Argentinean flare. He is seen here enjoying a Malbec with his wife, Angela. (Courtesy of James Skogsberg.)

In 2011, Wayne and Carol Milberger opened their Kerrville Hills Winery on a hilltop location just north of Kerrville. Upon arrival, visitors should look at the floor, fireplace, and chimney in the middle of the tasting room (pictured). Remnants of a burned-down house on this site, they were incorporated into the winery's unique design. (Courtesy of James Skogsberg.)

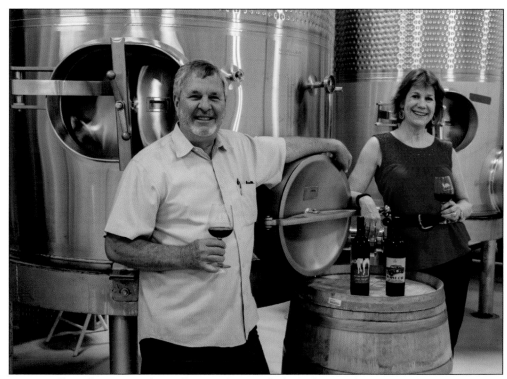

At Kerrville Hills Winery, the Milbergers (pictured) show their tank room, used to store wine in production. They make a range of wines from California and Texas appellations and offer a fun tasting experience. Texas wines include Syrah, Orange Muscat, and Blanc Du Bois. (Courtesy of James Skogsberg.)

After purchasing property near Comfort in 1993, Dick Holmberg (pictured) and his wife, Julie, decided to move from Houston to the property and plant a Merlot vineyard. By 2004, their whirlwind venture came to a head with the opening of their Singing Water Vineyards winery. (Courtesy of James Skogsberg.)

Singing Water Vineyards wines include Sauvignon Blanc, Merlot, Texas Reserve, and Freedom (a premium blend of Syrah, Cabernet Sauvignon, and Merlot). A portion of the proceeds from Freedom sales go to the Fisher House Foundation to fund college scholarships for children of active duty, retired, and deceased military personnel. (Courtesy of Singing Water Vineyards.)

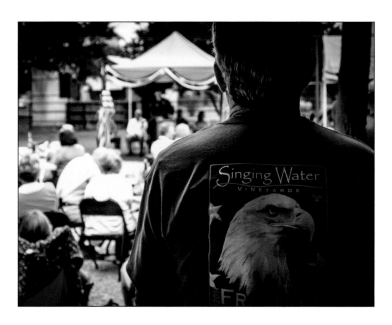

Bob Young (right) and son-in-law John Rivenburgh (left) work their Bending Branch Winery and vineyards near Comfort. They only grow grapes they believe will thrive in Texas: Petite Sirah, Picpoul Blanc, Cabernet Sauvignon, Souzão, Vermentino, and Tannat.

From a patron's first visit to the Bending Branch Winery tasting room, they see that the proprietors are doing things with forethought. The estate vineyard was established up on the hill to minimize late spring freeze damage. The Texas Tannat has quickly emerged as the champion of the winery's Texas terroir. (Courtesy of James Skogsberg.)

Bending Branch, while a boutique winery, is on the forefront of fermentation science. It uses cryo-maceration (CM), which employs freezing temperatures, and flash détente (unit shown here), which involves rapid heating/cooling, to extract more flavor and aroma compounds to make better wines. The winery's 2012 CM Estate Tannat won the Best Texas Wine Award in the 2014 Houston Livestock Show and Rodeo International Wine Competition. (Courtesy of Bending Branch Vineyards.)

Sister Creek Vineyards, housed in a historic 1885 cotton gin, is located in the tiny hill country town of Sisterdale, north of Boerne. For 26 years, it employed old-world Bordeaux and Burgundian winemaking techniques to produce traditional European-styled wines. Winemaker Danny Hernandez originally had no winemaking experience. He started at Sister Creek as caretaker, planting its first five-acre vineyard. (Courtesy of James Skogsberg.)

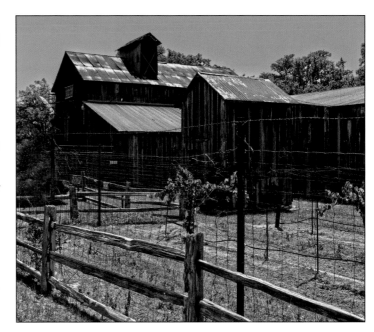

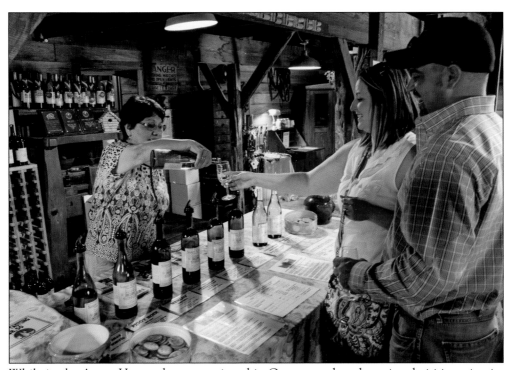

While in the Army, Hernandez was stationed in Germany, where he enjoyed visiting wineries and developed an interest in wine. After planting the Sister Creek estate vineyard, Hernandez started making wine with the help of California consultant Enrique Ferro. One popular wine in the tasting room (pictured) is the slightly carbonated, Italian-style Muscat Canelli. (Courtesy of James Skogsberg.)

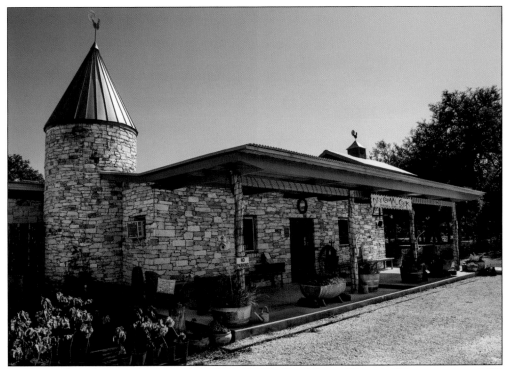

In 1975, looking for a site for their retreat from city life, Franklin and Bonnie Houser purchased 103 acres of land on Dry Comal Creek, just outside of New Braunfels. Franklin's love of wine developed in Europe, and this led them to plant grapes in Texas. In 1995, they had their first harvest, and the Dry Comal Creek winery became a reality in 1998. (Courtesy of James Skogsberg.)

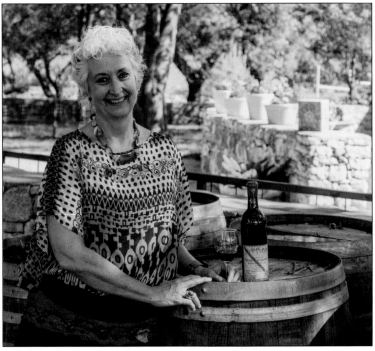

Despite two catastrophic floods, Franklin and his daughter Sabrina Houser (shown here) continue to run this destination winery and vineyard, best known for a unique red table wine they make from Black Spanish grapes (also called Lenoir) that grow in their estate vineyard. (Courtesy of James Skogsberg.)

Seven

THE TEXAS HILL COUNTRY
STILL GROWING AND MORE TO OFFER

Time to relax with a glass of Texas hill country wine and plan a winery adventure. This book will help guide a visit to the hill country wineries while also providing background on their heritage. As the number of hill country wineries continues to grow, wine trail websites, blogs, and *Twitter* and *Facebook* groups (see page 127) will extend what the reader finds in this book. This chapter presents some of the newest wineries (some not yet on the trail map). It also highlights vineyards (the basis of every wine region), events, wine and food activities, and knowledgeable people to help in the search for the best of Texas hill country wine experiences. Please consult the maps at the end of this chapter.

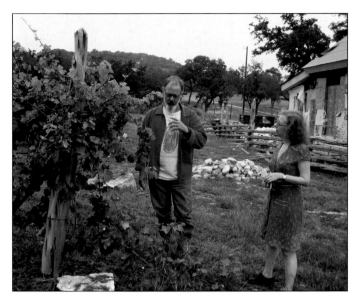

For natural wine, see Lewis Dickson (by appointment) at La Cruz de Comal Winery in Starzville. He is shown here in his vineyard with wine journalist Alice Feiring. Since 2001, the winery has been a collaboration between old friends: California winemaker Tony Coturri and Texas lawyer and wine enthusiast Dickson. Their wines are made with local grapes, native yeasts, and no sulfite additions. These wines are literally still alive in the bottle.

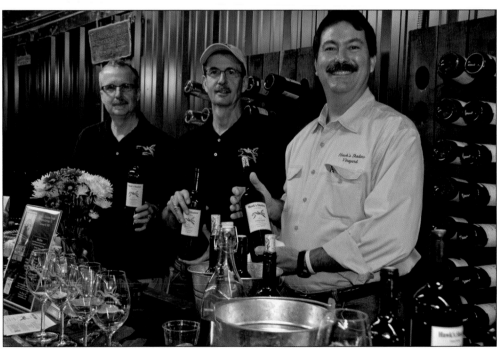

From left to right, Hawk's Shadow Winery partners Tom and Doug Reed and Chip Concklin pour wine at Hye Market. Their tasting room near Dripping Springs, opened in 2013 (Saturdays and by appointment), has over seven acres of hilltop and hillside vineyards that they started in 2005. Hawk's Shadow focuses on Italian, Spanish, and French southern grape varieties. (Courtesy of Miguel Lecuona, Wine Marketing Guide LLC.)

Mason resident Mark Watson and Robert Nida, who had winemaking experience in Texas, France, Spain, and South Africa, describe their approach at Compass Rose Cellars as "blending Old World techniques, a little bit of love, and a pinch of perseverance." They recently opened their tasting room (pictured) in Hye (consult for hours). (Courtesy of Miguel Lecuona, Wine Marketing Guide LLC.)

Carl Money, seen here in his Fredericksburg tasting room, presents his wines and talks with customers. He established his vineyard and refurbished a farmhouse in Pontotoc. Carl, his wife Frances, and his uncle Ronnie are working on turn-of-the-century sandstone buildings in Pontotoc for the future home of his Pontotoc Vineyard winery and tasting room, as well as "a commune" for his local winemaker friends.

After a football career, including being an All-American and an Oakland Raider, ex-Houstonian Alphonse Dotson and his wife, Martha Cervantes, established a vineyard near the small town of Voca. Recently, they started making their own wine (Wines of Dotson-Cervantes) and plan to open their tasting room in Pontotoc next door to Pontotoc Vineyard.

Consultant winemaker Don Pullum, shown with fellow contestants from the ABC cooking reality show *The Taste*, plans to have his Akashic Vineyard Winery housed in a historic barbershop with Pontotoc Vineyard. He also has plans to use the old movie theater next door as a venue for film screenings, live music, and theatrical performances.

If a quality wine region starts in the vineyard, for the Texas hill country it starts with Drew Tallent (pictured) in Mason. After growing peanuts and cotton, Tallent has for over 15 years grown grapes that have received critical acclaim in wines from Becker Vineyards and other wineries. Tallent Vineyard is the highest-producing and highest-quality vineyard in the hill country, with both classic French varieties and those from Mediterranean climes.

With no prior winegrowing experience, up-and-comer Dan McLaughlin assumed ownership of Robert Clay Vineyards in 2012. Prior to McLaughlin's purchase, this vineyard sat untended for years. Here, McLaughlin (right) and colleague Lex Fleming tend the grapes that have brought this vineyard back to nearly full production. On a freezing 2014 spring night, the men burned hay bales to save their grapes.

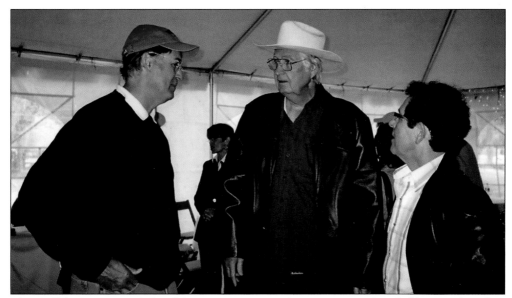

The Buffalo Gap Wine & Food Summit is a nonprofit organization founded by noted cowboy chef Tom Perini of Perini Ranch Steakhouse, the late Fess Parker of Fess Parker Winery, and Dr. Richard Becker of Becker Vineyards. Becker (left) and Parker (center) organized this summit to feature Texas wines and those from California wineries that have Texas connections. (Courtesy of Becker Vineyards.)

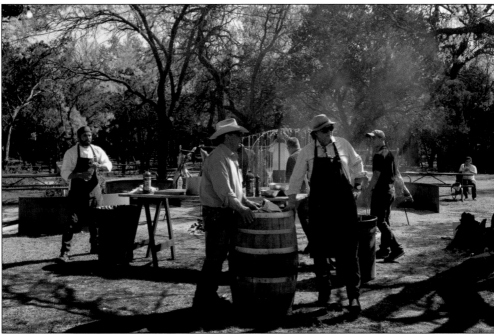

The Buffalo Gap Wine & Food Summit began including wines, winemakers, and cuisine from other regions (Rhone Valley, Tuscany, Spain, and Argentina) with educational sessions, Texas and regional wine industry discussions, and tasting panels. Here, Tom Perini (right) cooks on an open fire with Argentine grill master Francis Mallmann, author of Seven Fires: Grilling the Argentine Way. The food was served with lots of Malbec from Texas, Argentina, and California.

Master sommelier Guy Stout leads a Texas, California, and Argentine wine-tasting panel at the Buffalo Gap Summit. He said, "Texas is a far cry from the other wine-growing regions of the world. There are still lots of challenges." His 15 years of wine-growing experience in the hill country's Blanco County taught him about freezes, frosts, bugs, and birds. He advises, "Next time you buy a bottle of Texas wine, think about what it took to produce it!"

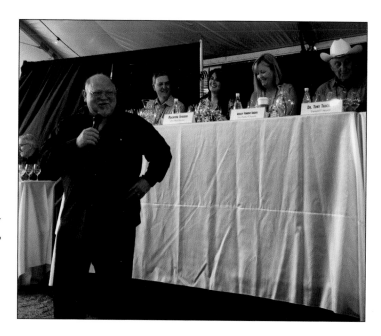

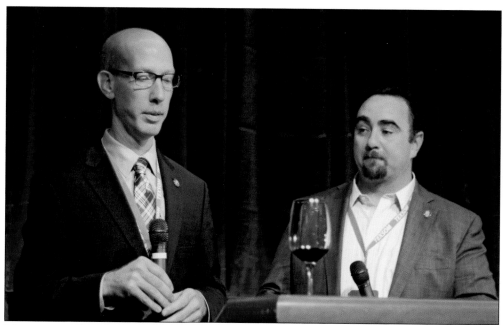

Master sommeliers James Tidwell (left) and Drew Hendricks started Texsom, an event focusing on wine and beverage education for restaurant and wine-service professionals. They admit that what started with only a few people has now become a national sold-out conference. This event helps display the best Texas wines alongside major national and international brands. (Courtesy of Matt McGinnis, www.whatareyoudrinking.net.)

Chef Ross Burtwell, owner of Cabernet Grill in Fredericksburg, has an all-Texas wine list. He said, "When I decided to make the restaurant's wine list all-Texas, it was based on an appreciation for what Texas winemakers were doing and the confidence that they would make excellent wines for years. Great new wineries have joined old standbys, and they're producing the great wines that I'm proud to serve." (Courtesy of Steve Rawls.)

Adam Ehmer, previously general manager and sommelier at Otto's Restaurant in Fredericksburg, said, "I'm excited by our hill country winemakers that are focused on local expression. Single vineyard wines from Tallent Vineyard, Parr Vineyard, Granite Hill [William Chris Vineyards], Kuhlken Estate [Pedernales Cellars], Pontotoc, Spicewood, Lewis Wines Round Mountain, and the Bending Branch Estate all reveal facets of our hill country terroir."

Author and chef Terry Thompson Anderson states, "The Texas wine industry may be at a crossroads, but it is also on the road to greatness. Winemakers are learning that success of any wine begins with planting the right grape varieties in the right soil, in the right place, and giving them the best management. One of the remaining challenges is gaining national recognition of today's fine Texas wine quality." (Courtesy of Sandy Wilson Photography.)

Steven Krueger was sommelier at La Cantera Hill Country Resort in San Antonio for years and has likely introduced more people to their first taste of Texas wine than anybody. He calls this "a most exciting time for the Texas wine industry; vineyards are growing warm climate grapes that do well here and are planting increasing acreages." He is now at Arcade Midtown Kitchen in "The Pearl" in San Antonio. (Courtesy of Dee Dee Hale.)

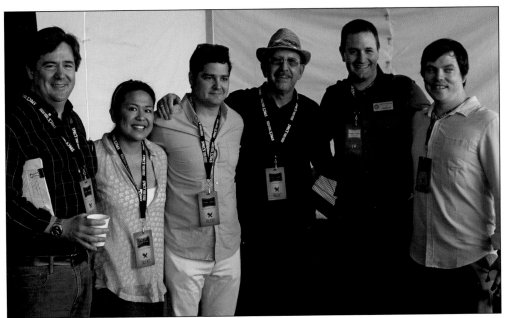

The Austin Food & Wine Festival took over the Hill Country Wine & Food Festival operations. In 2012, gold-medal-winning Texas wines were featured by a panel including, from left to right, Ray Isle, executive wine editor, *Food & Wine* magazine; advanced sommelier June Rodil; master sommelier Devon Broglie; moderator Russ Kane (www.vintagetexas.com); Messina Hof owner Paul Mitchell Bonarrigo, whose wine was featured on the panel; and master sommelier Craig Collins. (Courtesy of Matt McGinnis, www.whatareyoudrinking.net.)

Pictured here are some of the Texas wine media and others that have furthered their wine credentials with certifications at Texsom 2013. They are, from left to right, Jennifer Dupuy (*Texas Monthly*), Jenny Gregorcyk (Hahn Public Communications), Frederik Osterberg and Julie Kuhlken (Pedernales Cellars), Denise Clarke (DC Communications), Russ Kane (www.vintagetexas.com), and Matt McGinnis (freelance writer). (Courtesy of Matt McGinnis, www.whatareyoudrinking.net.)

These maps show the many wineries on the Texas hill country wine trail. (Courtesy of Billy Burdett, Press Corps.)

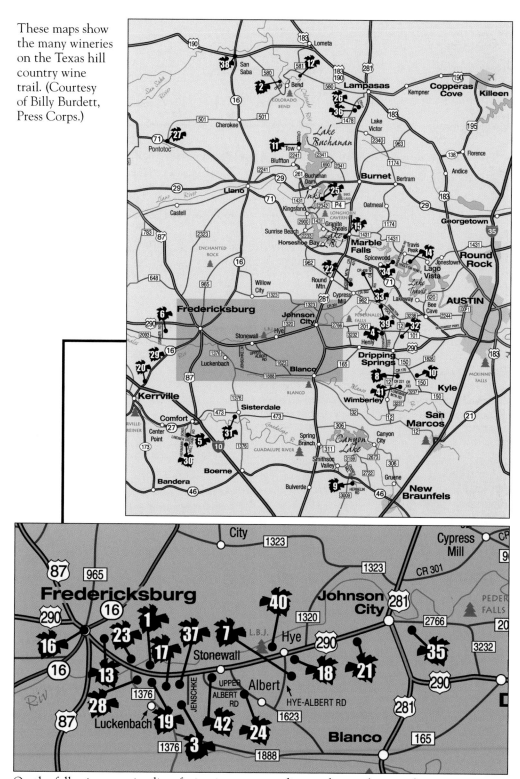

On the following page is a list of wineries corresponding to the numbers on the maps.

List of Wineries
on Page 93

1. 4.0 Cellars
2. Alamosa Wine Cellars
3. Becker Vineyards
4. Bell Springs Winery
5. Bending Branch Winery
6. Chisholm Trail Winery
7. Compass Rose Cellars
8. Driftwood Estate Winery
9. Dry Comal Creek Vineyards
10. Duchman Family Winery
11. Fall Creek Vineyards
12. Fiesta Winery
13. Fiesta Winery 290
14. Flat Creek Estate
15. Flat Creek Enoteca
16. Fredericksburg Winery
17. Grape Creek Vineyards
18. Hye Meadow Winery
19. Inwood Estate Winery/Bistro
20. Kerrville Hills Winery
21. Lewis Winery
22. McReynolds Winery
23. Messina Hof Hill Country
24. Pedernales Cellars
25. Perissos Vineyards/Winery
26. Pillar Bluff Vineyards
27. Pontotoc Vineyard
28. Rancho Ponte Vineyard
29. Santa Maria Cellars
30. Singing Water Vineyards
31. Sister Creek Vineyards
32. Solaro Estate Winery/Vineyards
33. Spicewood Vineyards
34. Stone House Vineyard
35. Texas Hills Vineyard
36. Texas Legato Winery
37. Torre di Pietra Vineyards
38. Wedding Oak Winery
39. Westcave Cellars Winery
40. William Chris Vineyards
41. Wimberley Valley Winery
42. Woodrose Winery

Current and more detailed information on each winery at www.texaswinetrail.com

BIBLIOGRAPHY

English, Sarah Jane. *The Wines of Texas: A Guide and a History*. Austin, TX: Eakin Press, 1986, 1995.

Giordano, Frank. *Texas Wines & Wineries*. Austin, TX: Texas Monthly Press, 1984.

Kane, Russell D. *The Wineslinger Chronicles: Texas on the Vine*. Grover E. Murray Studies in the American Southwest. Lubbock: Texas Tech University Press, 2012.

McLeroy, Sherrie S., and Roy E. Renfro Jr. *Grape Man of Texas*. San Francisco: Tine Wine Appreciation Guild, 2008.

Munson, T.V. *Foundations of American Grape Culture*. Denison, TX: T.V. Munson & Sons, 1909.

Timmons, W.H. *El Paso: A Borderlands History*. El Paso, TX: Texas Western Press, 1990.

Websites for Texas wines and wineries:
www.gotexan.org
www.texaswineandtrail.com
www.texaswinetrail.com (Texas Hill Country Wineries Wine Trail)
www.txwinelover.com
www.txwines.org
www.vintagetexas.com
www.wineroad290.com
www.winesocietyoftexas.org